3 1842 02547 2315

W9-ATT-322

America THE *Beautiful*

NEW JERSEY

NORA CAMPBELL

Photographs by STEVE GREER

FIREFLY BOOKS

A FIREFLY BOOK

Published by Firefly Books Ltd. 2010

Copyright © 2010 Firefly Books Ltd.
Text copyright © 2010 Firefly Books Ltd.
Photography copyright © Steve Greer

All rights reserved. No part of this publication may be reproduced,
stored in a retrieval system, or transmitted in any form or by any means,
electronic, mechanical, photocopying, recording or otherwise, without
the prior written permission of the Publisher.

First printing

Publisher Cataloging-in-Publication Data (U.S.)

Campbell, Nora.
 New Jersey / Nora Campbell ; Steve Greer photography.
 [] p. : col. photos. ; cm. America the Beautiful series.
Summary: Captioned photographs showcase the remarkable architecture,
dynamic neighborhoods and exciting attractions of New Jersey.
ISBN-13: 978-1-55407-613-0 ISBN-10: 1-55407-613-7
1. New Jersey – Pictorial works. 2. New Jersey – Buildings, structures, etc. – Pictorial works.
I. Greer, Steve, ill. II. America the Beautiful / Dan Liebman. III. Title.
974.9 dc22 F135.C367 2010

Published in the United States by
Firefly Books (U.S.) Inc.
P.O. Box 1338, Ellicott Station
Buffalo, New York 14205

Published in Canada by
Firefly Books Ltd.
66 Leek Crescent
Richmond Hill, Ontario L4B 1H1

Cover and interior design: Kimberley Young

Printed in China

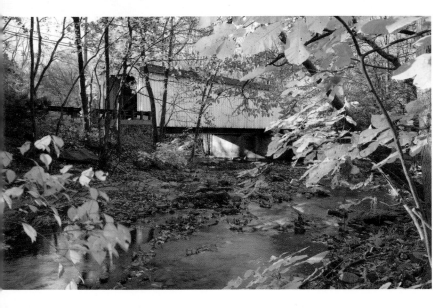

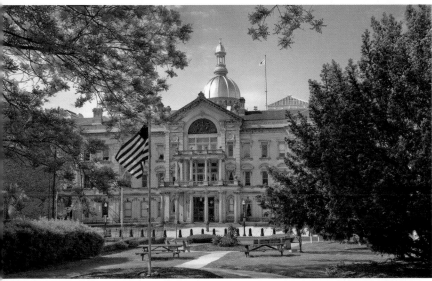

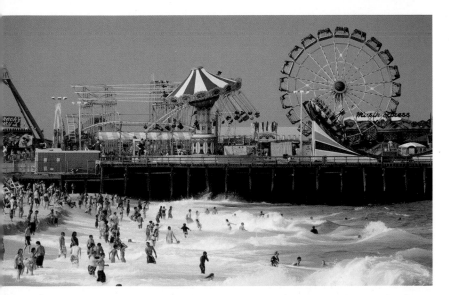

CULTURE, history, natural beauty and industry all live together in a fascinating state called New Jersey.

This is the third-oldest state in the nation, and it was here that many significant historic events happened, among them Washington's Battle at Trenton to defeat the British.

Although it's only the 46th state in terms of size (but the ninth in population), New Jersey offers an eclectic landscape. From the rugged Kittatinny Mountains, to the beautiful forests, to the more than 125 miles of white sandy beaches, New Jersey packs in a lot of geography. In addition, more than a million acres in the southern half of the state make up a national reserve known as the Pine Barrens. It offers an untamed tapestry of rivers, marshes and wilderness trails. There continues to be extensive efforts throughout the state for preserving wildlife habitats.

Of course, one of New Jersey's biggest draws is the renowned Atlantic City boardwalk. Founded in 1870, this four-mile-long stretch attracts thousands of visitors every year and offers something for everyone: the glitz and glamour of the casinos, designer shops, hot dog carts, souvenir stands and carnival rides. By contrast, Cape May, along with its award-winning beaches, offers an abundance of genteel Victorian charm. And miles of pristine shoreline offer settings for family fun or quiet solitude.

With a wealth of history and culture, of wilderness and entertainment, New Jersey has it all. Architectural treasures, Revolutionary War sites, mountains, miles of sandy beaches, picturesque lighthouses, and a profusion of flowering trees and botanical exhibits contribute to the essence of this aptly named "Garden State."

This book can provide only a taste of the state's visual beauty. It begins with a New Jersey sampler, then meanders through the picturesque regions. We hope you'll enjoy the many charms, attractions and surprises as you travel the pages of *America the Beautiful – New Jersey*.

New Jersey is a state of contrasts. The ubiquitous New Jersey diner is a classic part of Americana. For decades, great coffee, homemade meals and friendly smiles have been standard fare at the hundreds of diners across the state.

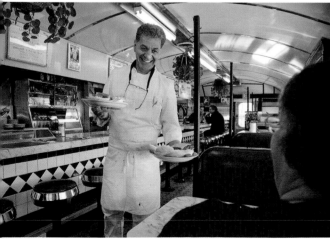

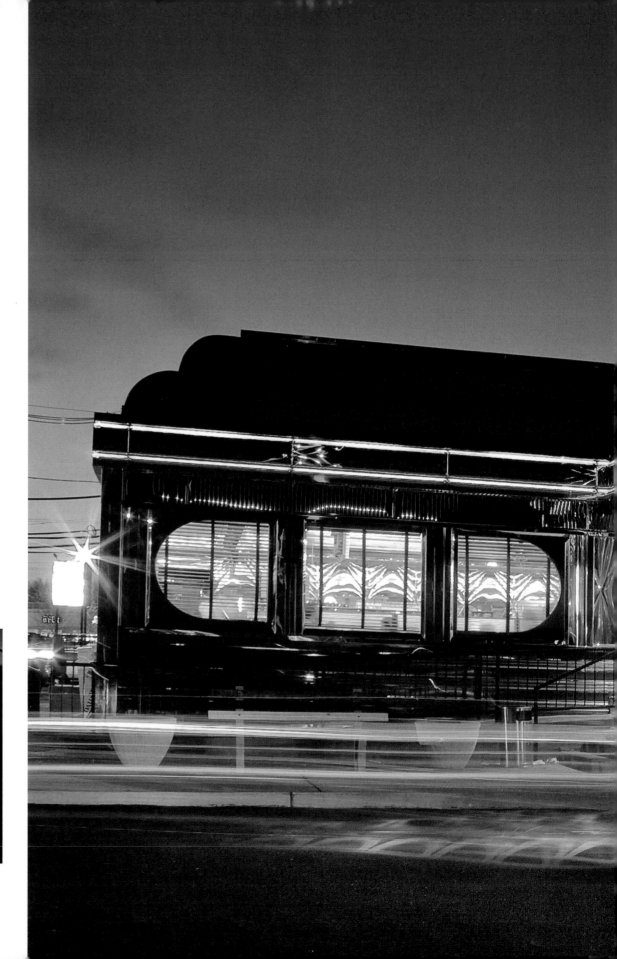

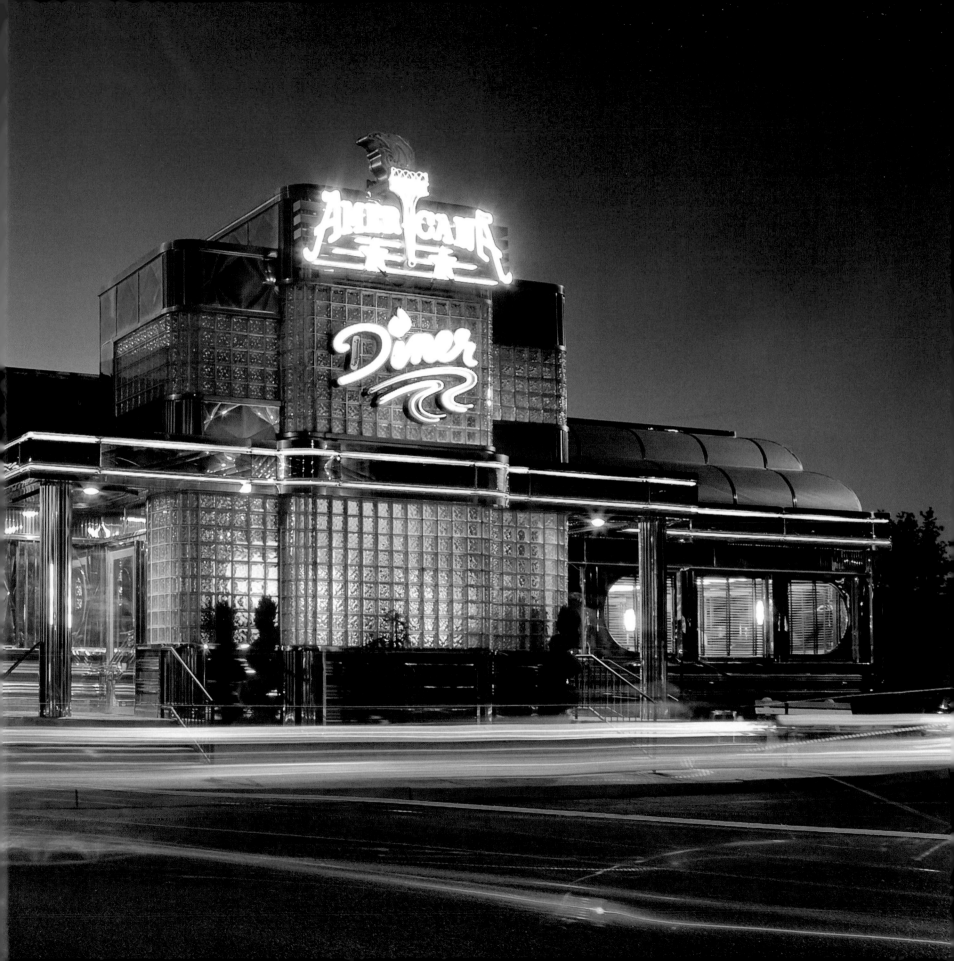

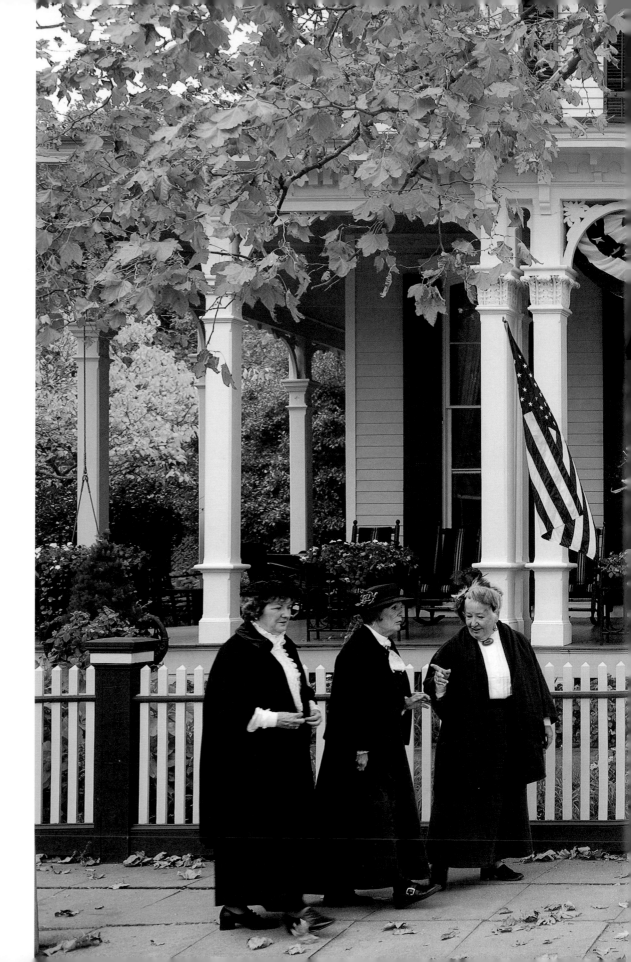

Cape May in the south, where the Delaware Bay meets the Atlantic Ocean, is rich in Victorian charm. The Mainstay Inn was built in 1872 as a private gambling club and has been recorded by the Historic American Buildings Survey. In 1972, the entire city of Cape May was placed on the National Register of Historic Sites.

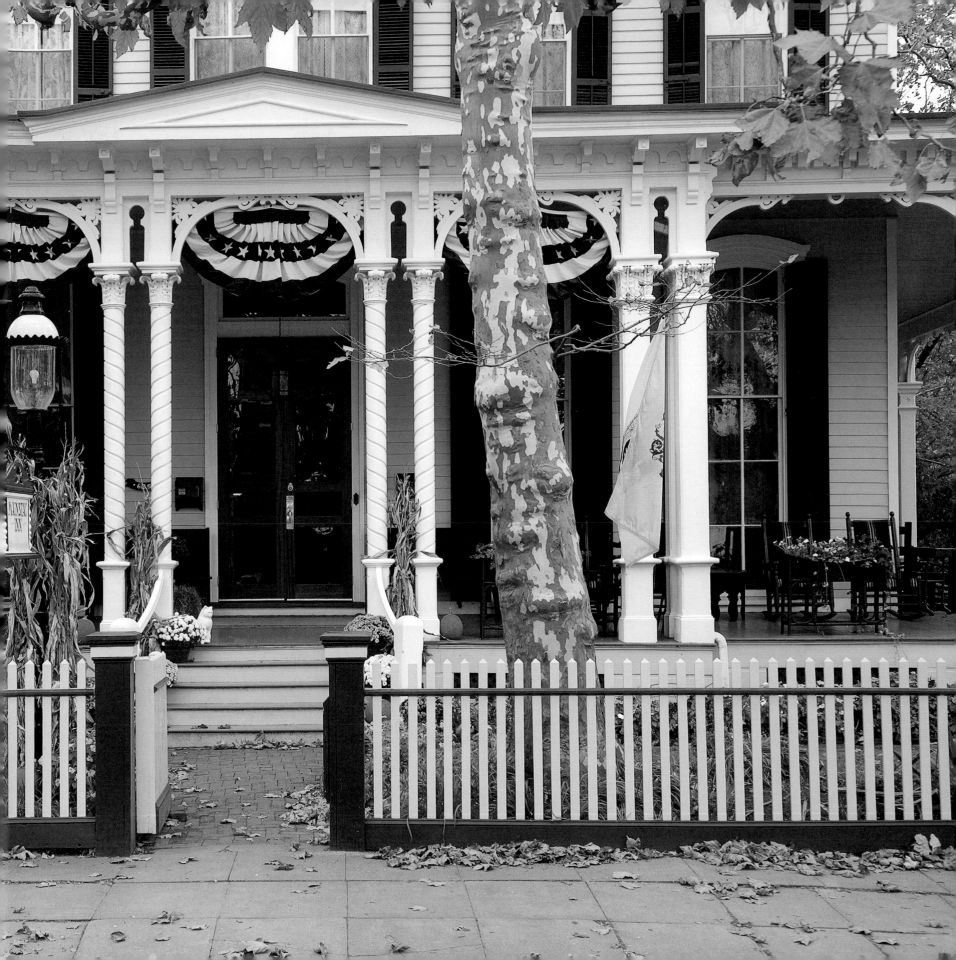

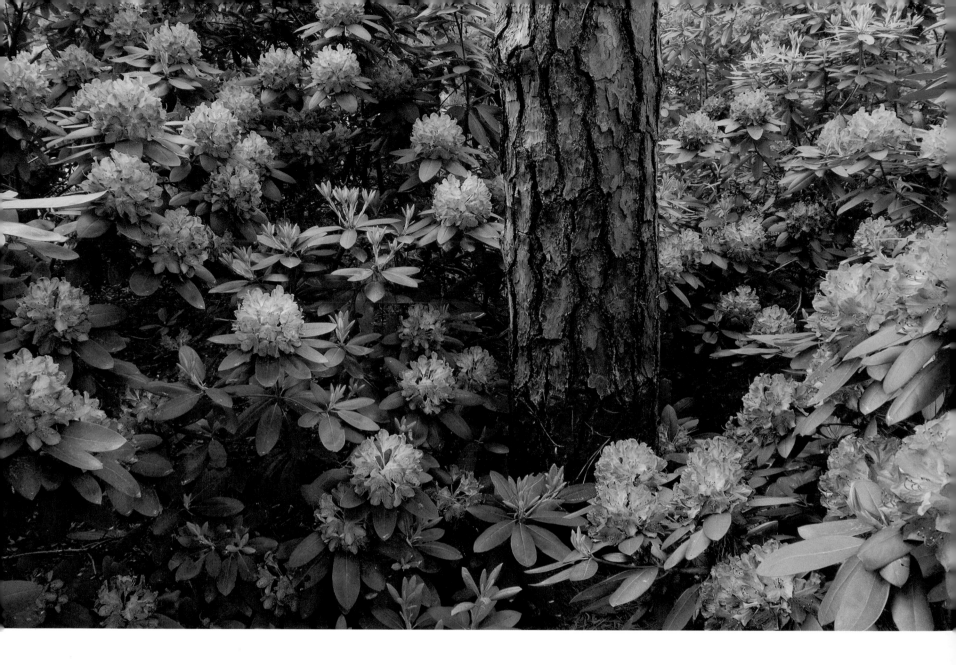

Masses of rhododendrons blanket the forested areas of the Pine Barrens. Situated between the New Jersey Turnpike and Garden State Parkway, this dense wilderness seems impervious to the pace of the century zooming alongside.

OPPOSITE PAGE: The Garden State lives up to its name with the many beautiful public parks and gardens throughout New Jersey. Each spring, over 2,000 cherry trees explode into bloom in Branch Brook Park in Newark. The park is the first county park to be opened for public use in the United States.

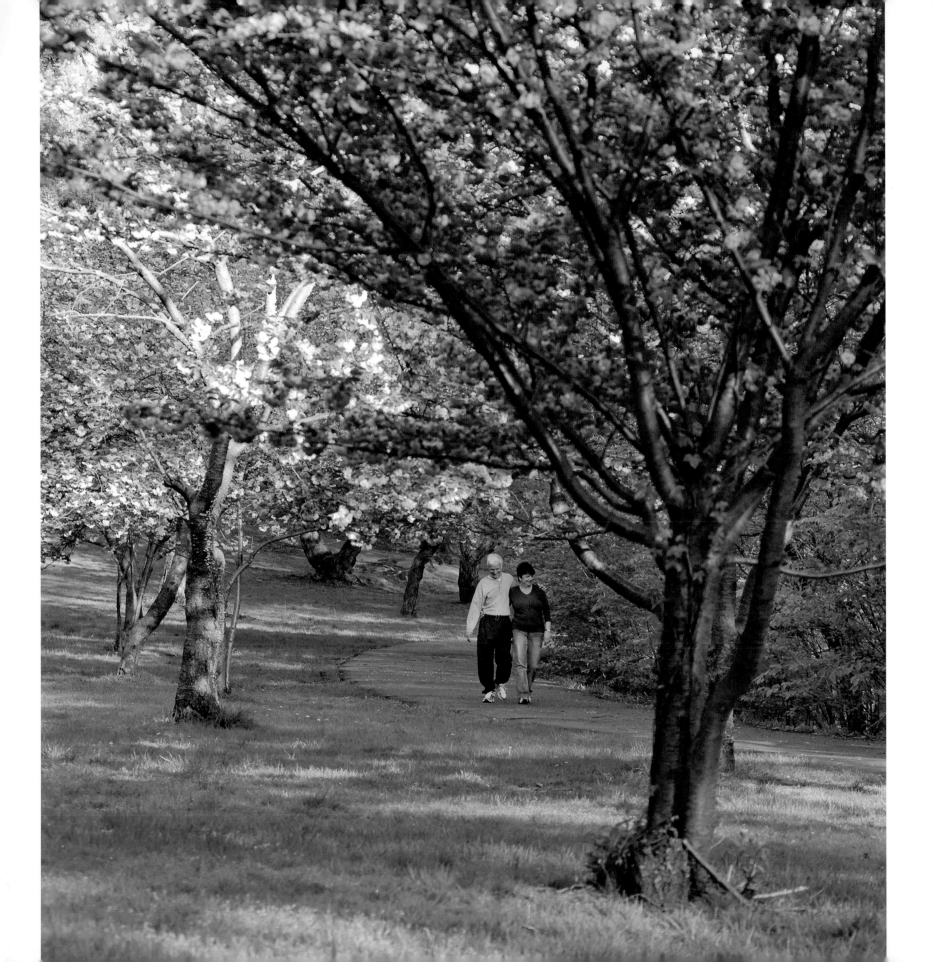

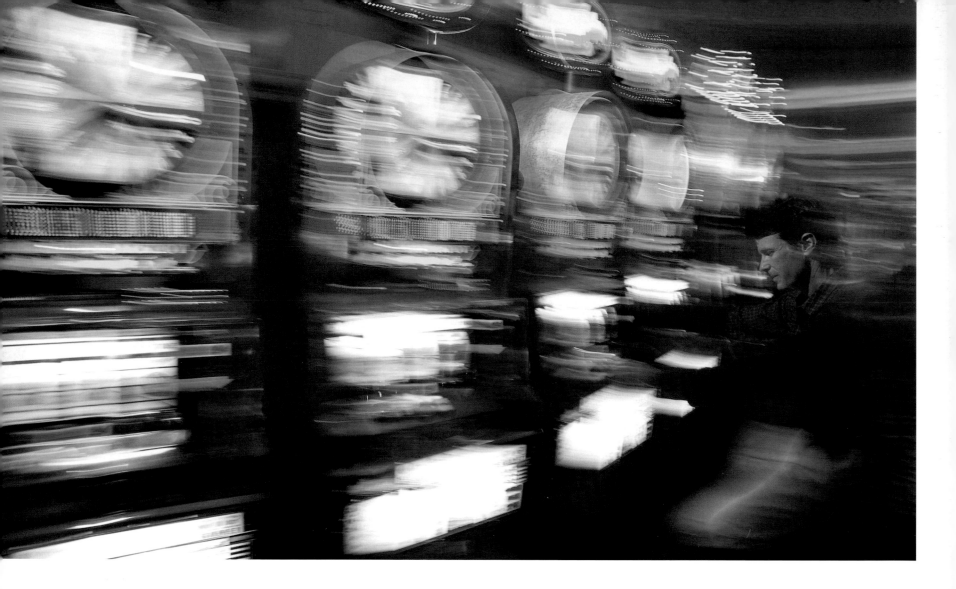

Fortunes are made and lost at the many lavish casinos in and around Atlantic City.
When the sun goes down, the action heats up!

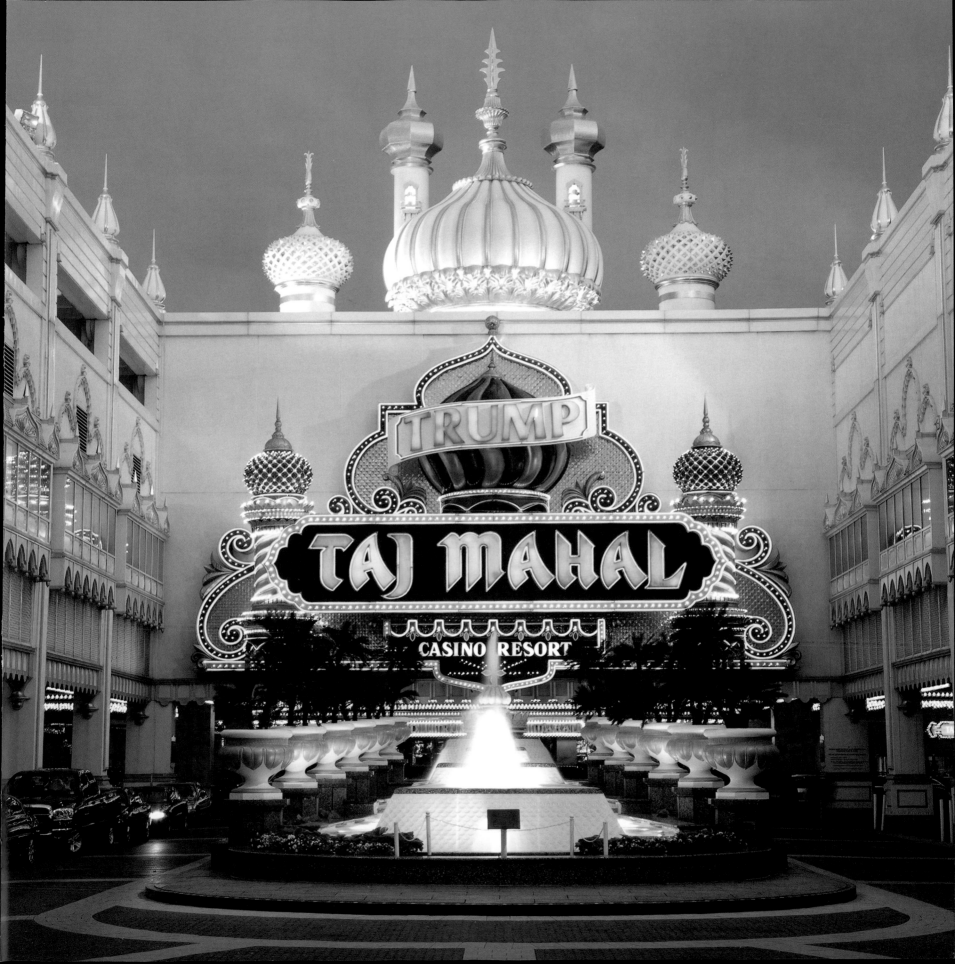

Since its opening in 1997, the New Jersey Performing Arts Center in Newark, named "the nation's most glamorous theater," has attracted several million patrons to a great variety of shows. It is also the home of the Grammy-winning New Jersey Symphony Orchestra.

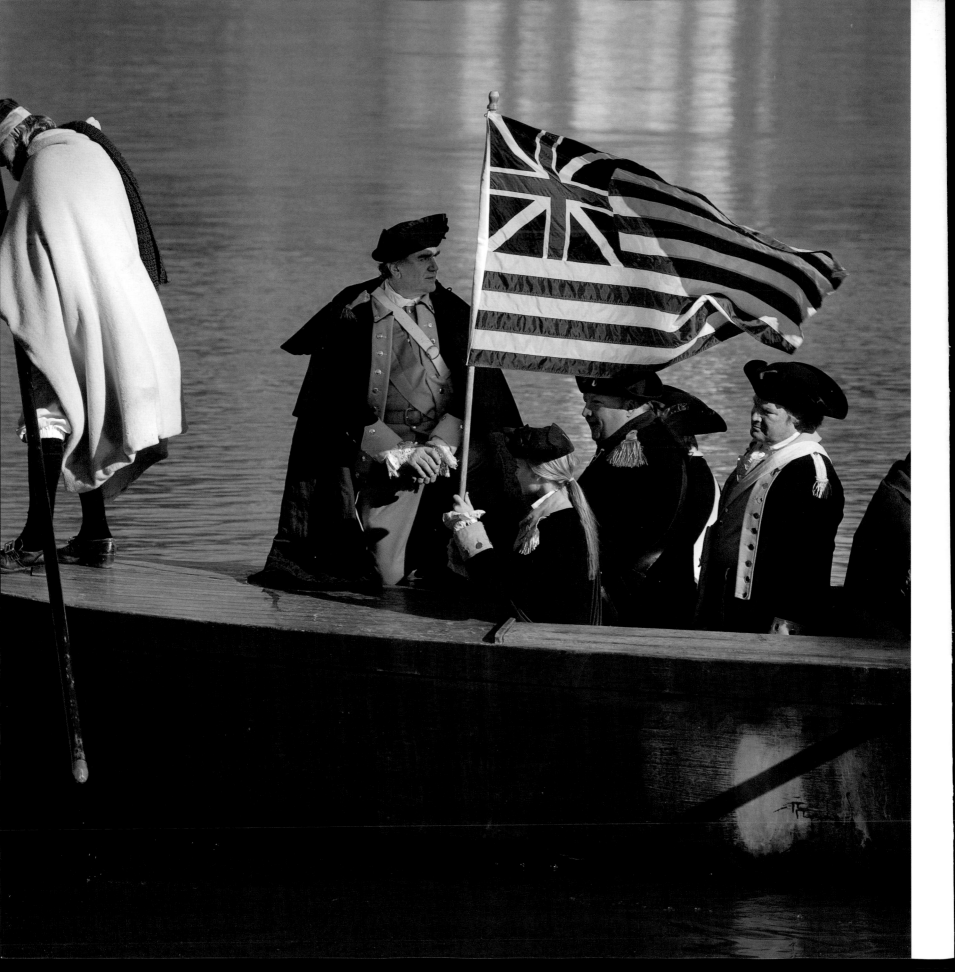

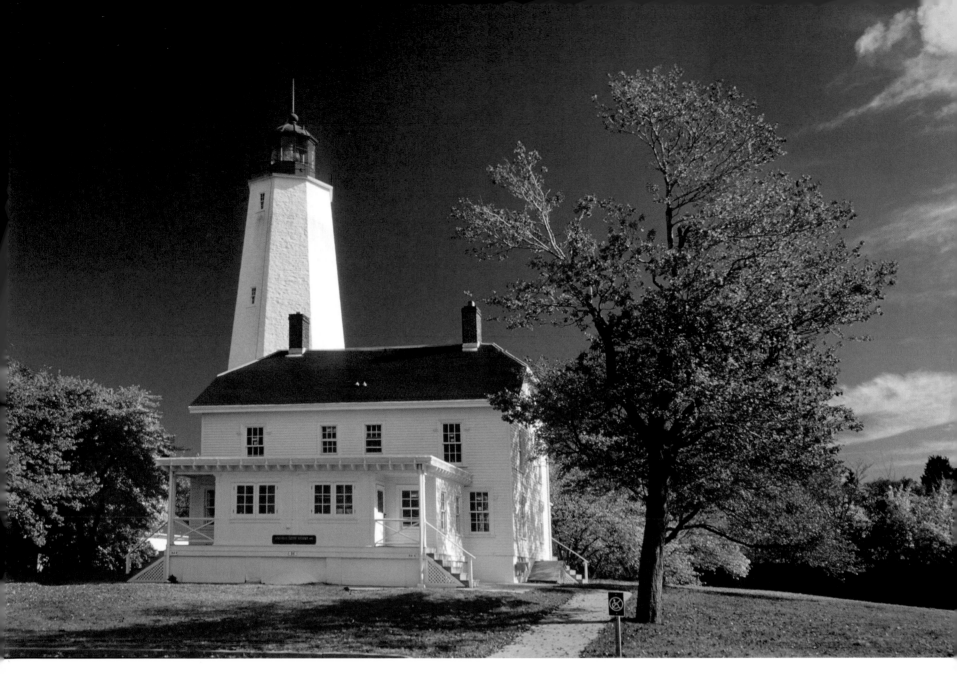

Sandy Hook lighthouse was built in 1764 to mark the entrance to New York Harbor. Originally discovered by the famous sea captain Henry Hudson in the early 1600s, Sandy Hook remains a beautiful 1,665-acre barrier peninsula.

OPPOSITE PAGE: On December 25, 1776, General George Washington and the Continental Army crossed the icy waters of the Delaware River, creating a pivotal event of the American Revolution. The site, now known as Washington Crossing State Park, just northwest of Trenton, sets the scene for Revolutionary War re-enactors.

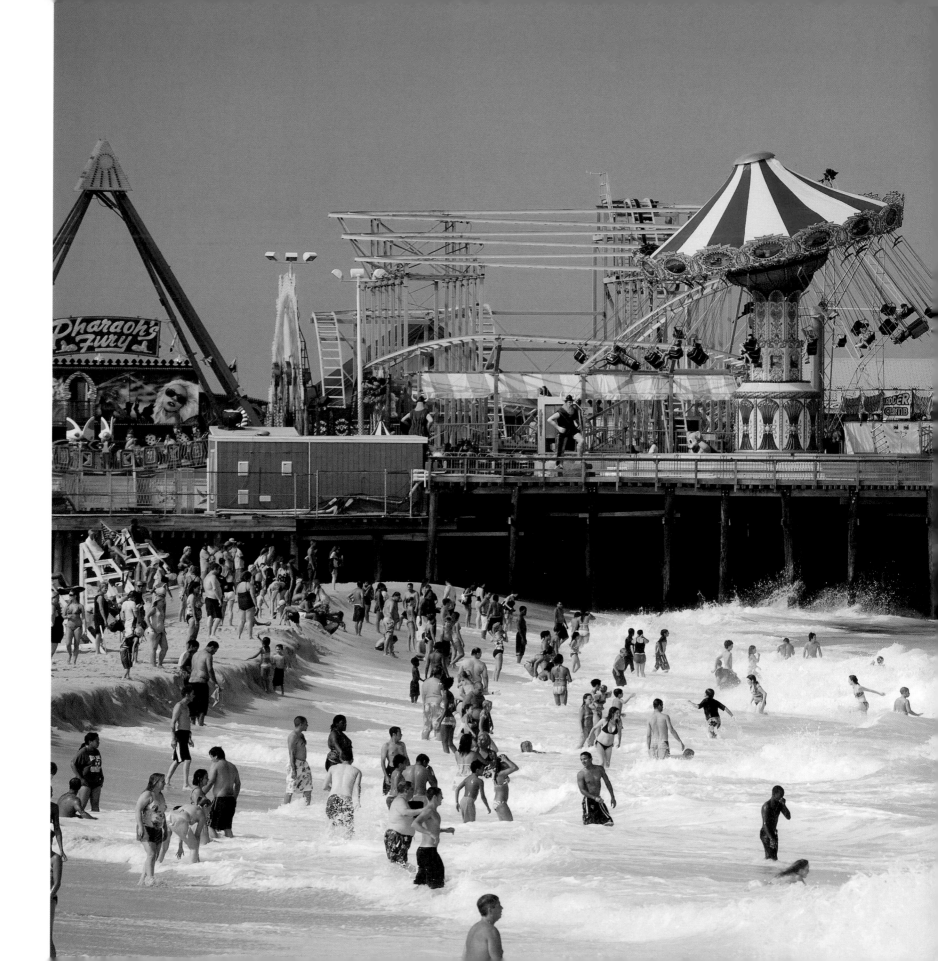

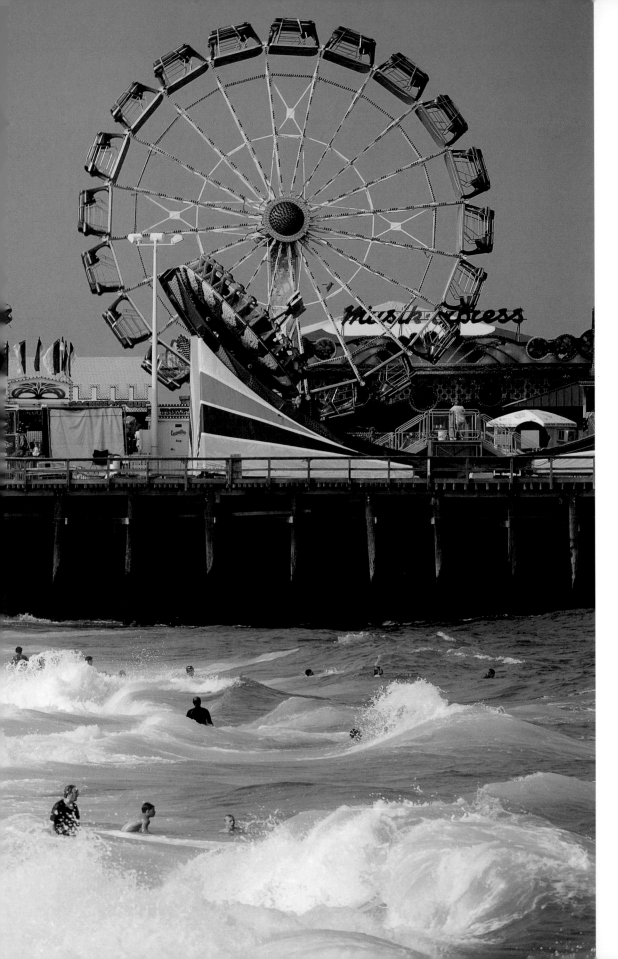

New Jersey offers plenty of seaside fun. Summer visitors play in the surf and enjoy the amusement rides and miles of sandy beaches at Seaside Heights on the Atlantic coast.

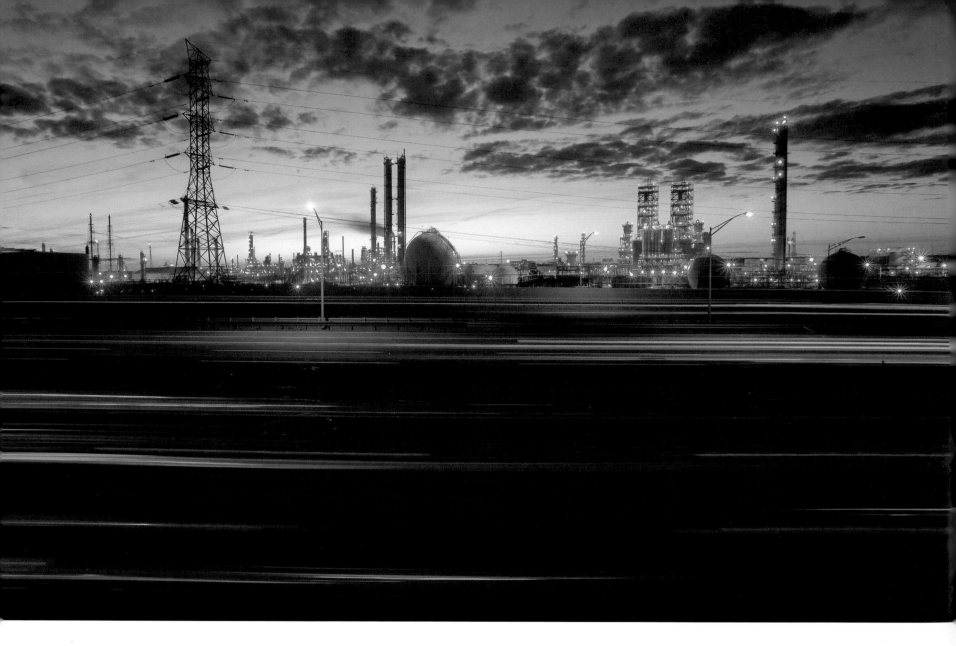

Long known as the center of oil-refining in the eastern United States, New Jersey operates several large plants along this heavily industrialized stretch of the Delaware River, off the New Jersey Turnpike.

OPPOSITE PAGE: The Statue of Liberty viewed from New Jersey's Liberty State Park.

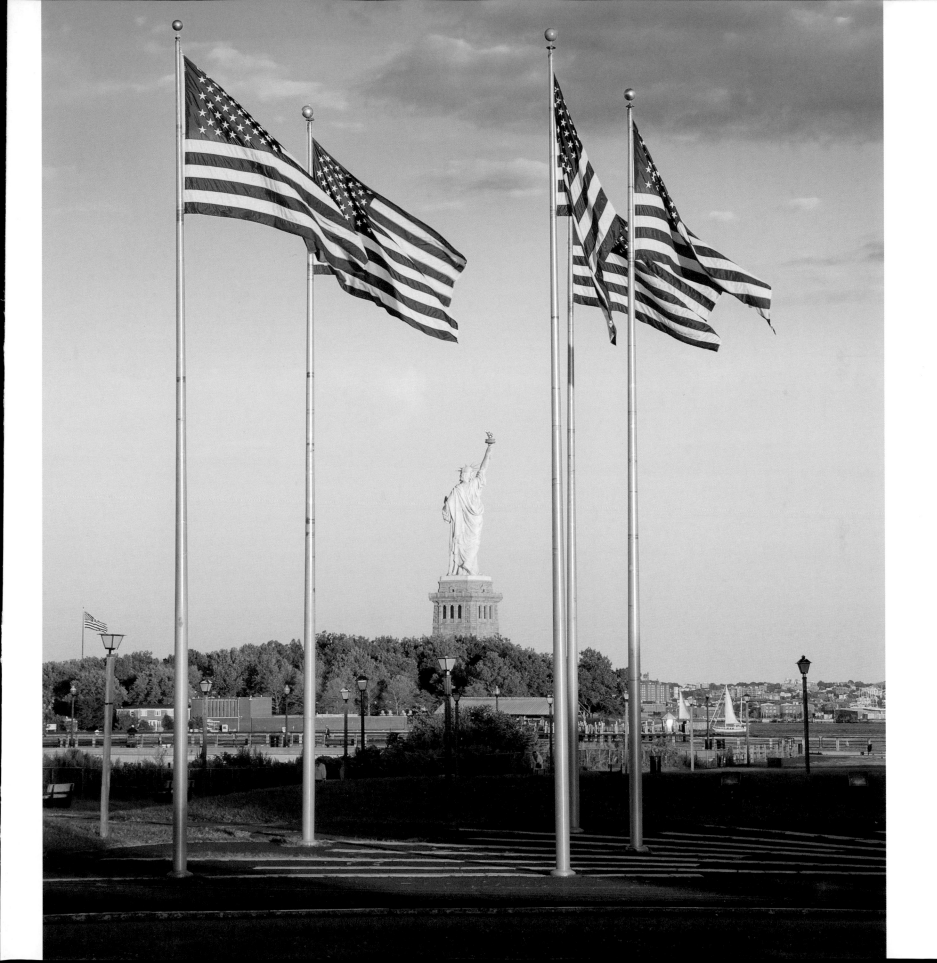

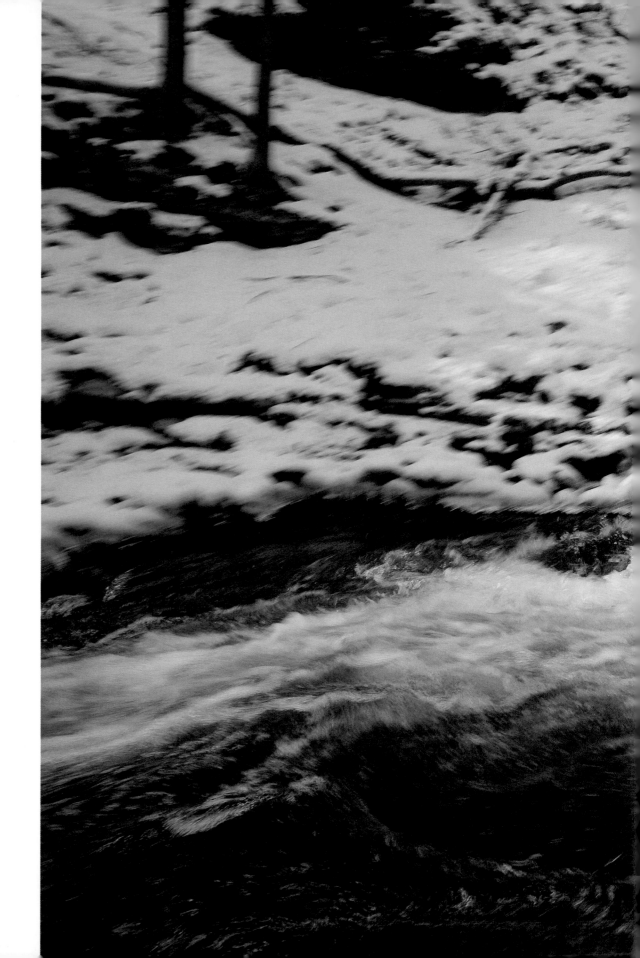

With the rush of the spring run-off, a kayaker maneuvers his way down the Flatbrook River, where the famed Delaware Water Gap cuts its way through the mountain ridges.

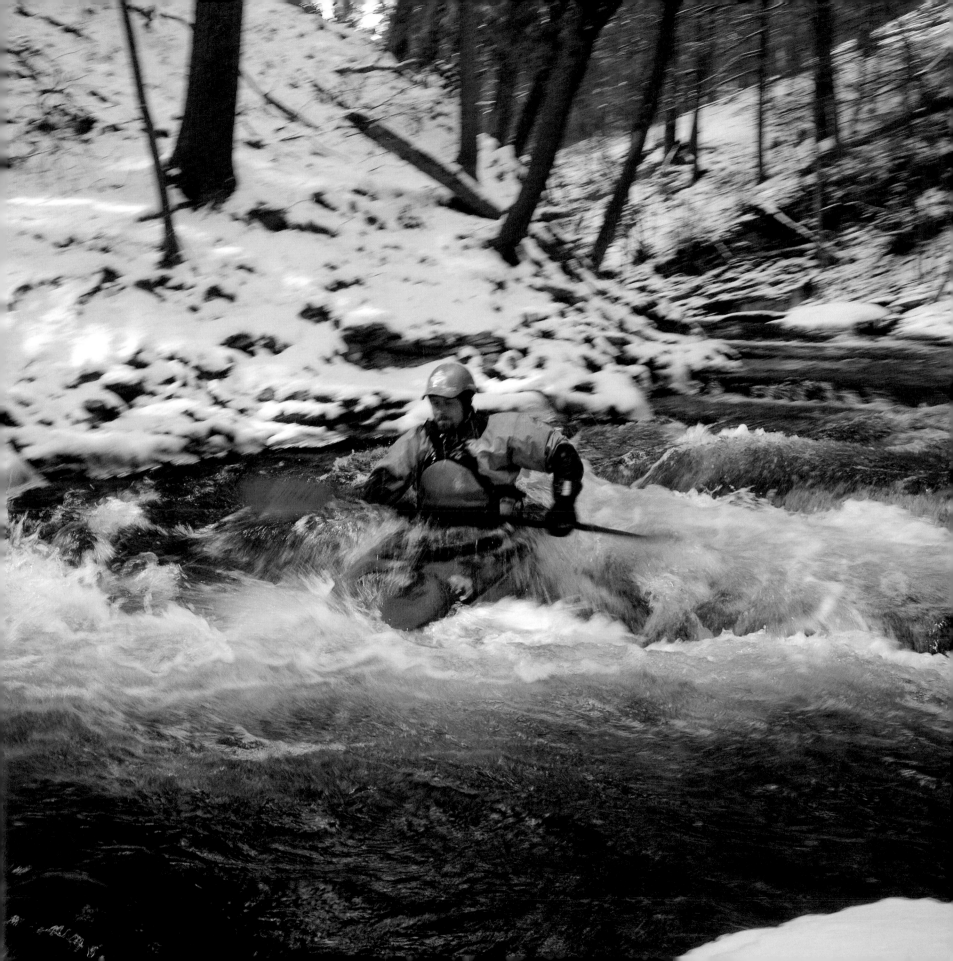

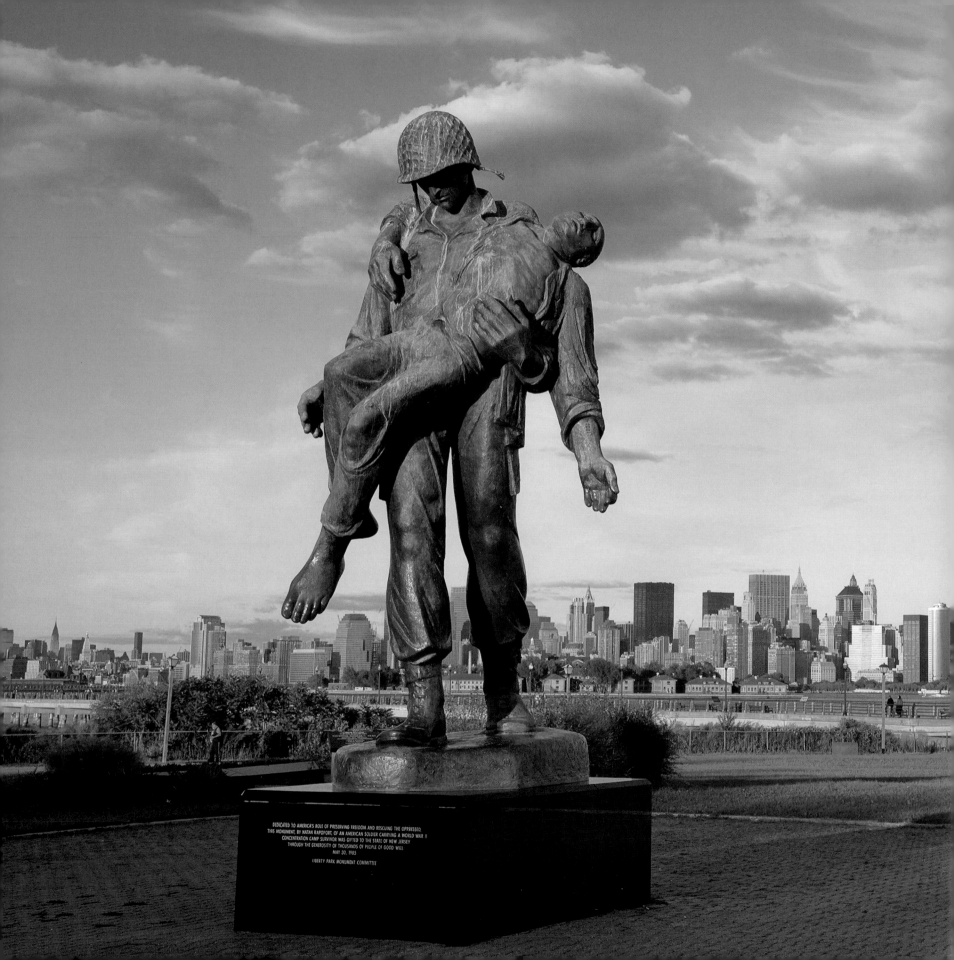

DEDICATED TO AMERICA'S ROLE OF PRESERVING FREEDOM AND RESCUING THE OPPRESSED,
THIS MONUMENT, BY NATAN RAPOPORT, OF AN AMERICAN SOLDIER CARRYING A WORLD WAR II
CONCENTRATION CAMP SURVIVOR WAS GIFTED TO THE STATE OF NEW JERSEY
THROUGH THE GENEROSITY OF THOUSANDS OF PEOPLE OF GOOD WILL.
MAY 30, 1985

LIBERTY PARK MONUMENT COMMITTEE

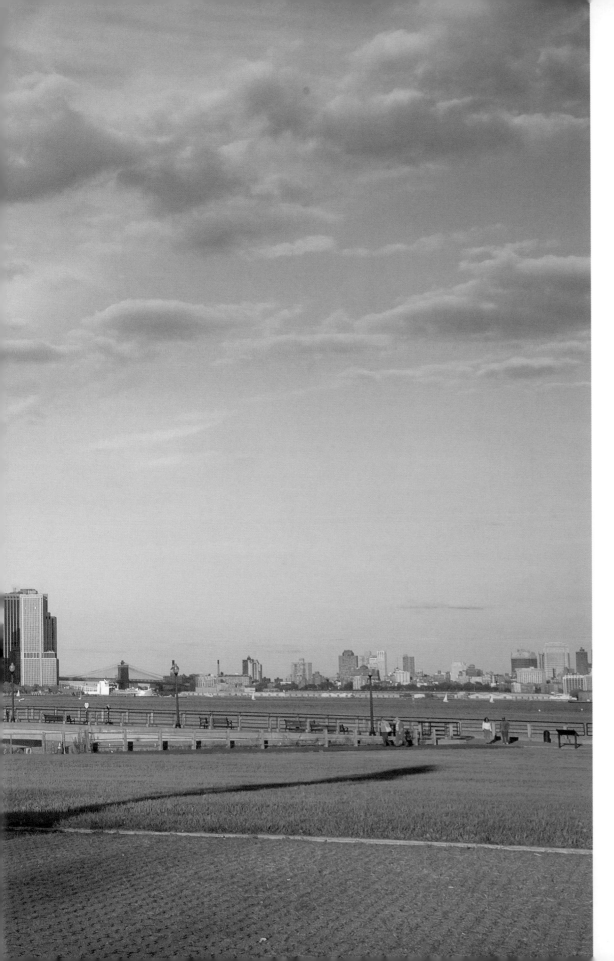

Set in New Jersey's Liberty State Park, not far from the Statue of Liberty in New York Harbor, this poignant memorial serves as a moving tribute to the sacrifices made during the Second World War.

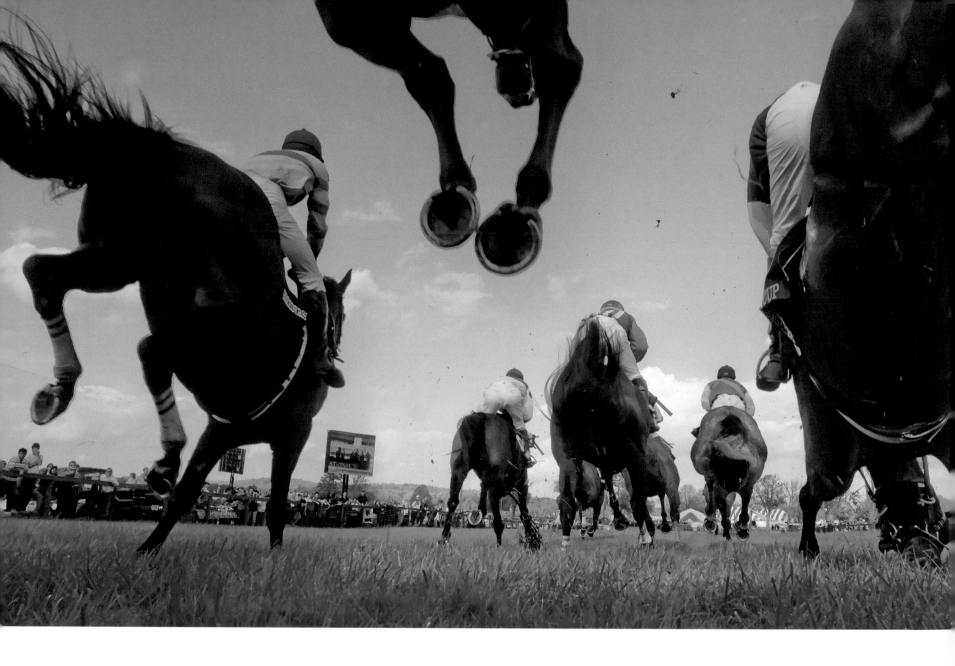

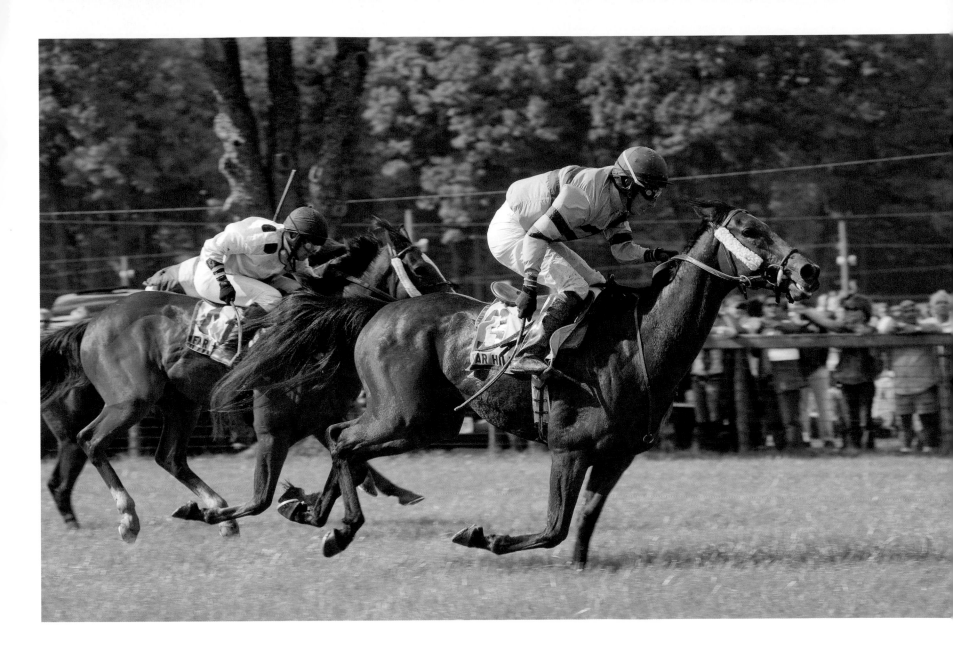

ABOVE & OPPOSITE PAGE: More than 50,000 spectators converge each fall on the rolling hills of Moorland Farms in Far Hills, west of Newark. This prestigious event features some of the finest steeplechasers in the world competing against a backdrop of autumn splendor. The Race Meeting hosts the Breeder's Cup Steeplechase, the nation's most prominent steeplechase race.

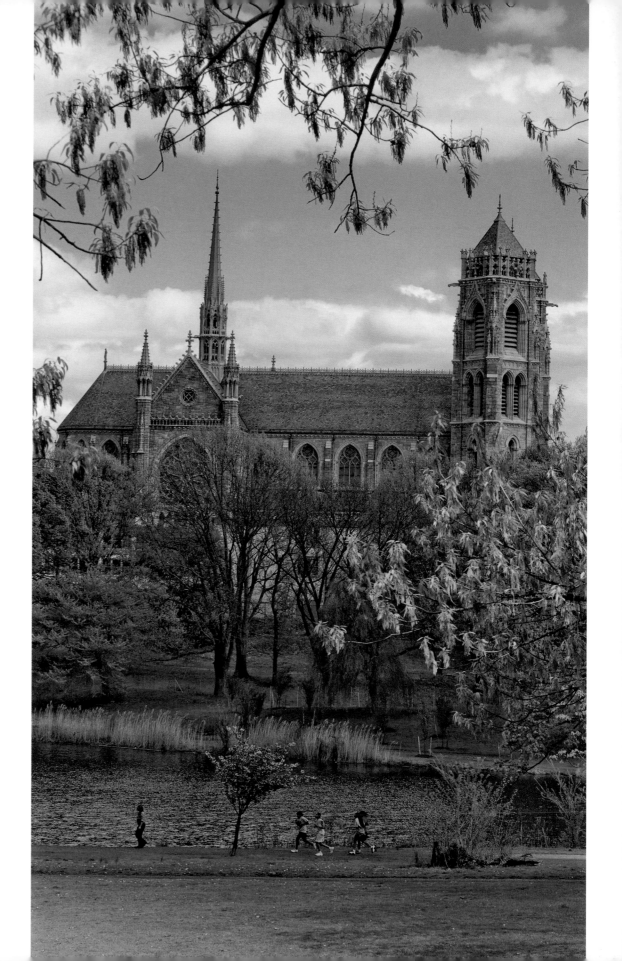

More than two thousand cherry trees blossom each April in Newark's Branch Brook Park.

OPPOSITE PAGE: The Great Falls of the Passaic River, northwest of New York City, are the center of the Paterson National Park, established in 2009. It is a uniquely urban national park with an important industrial history.

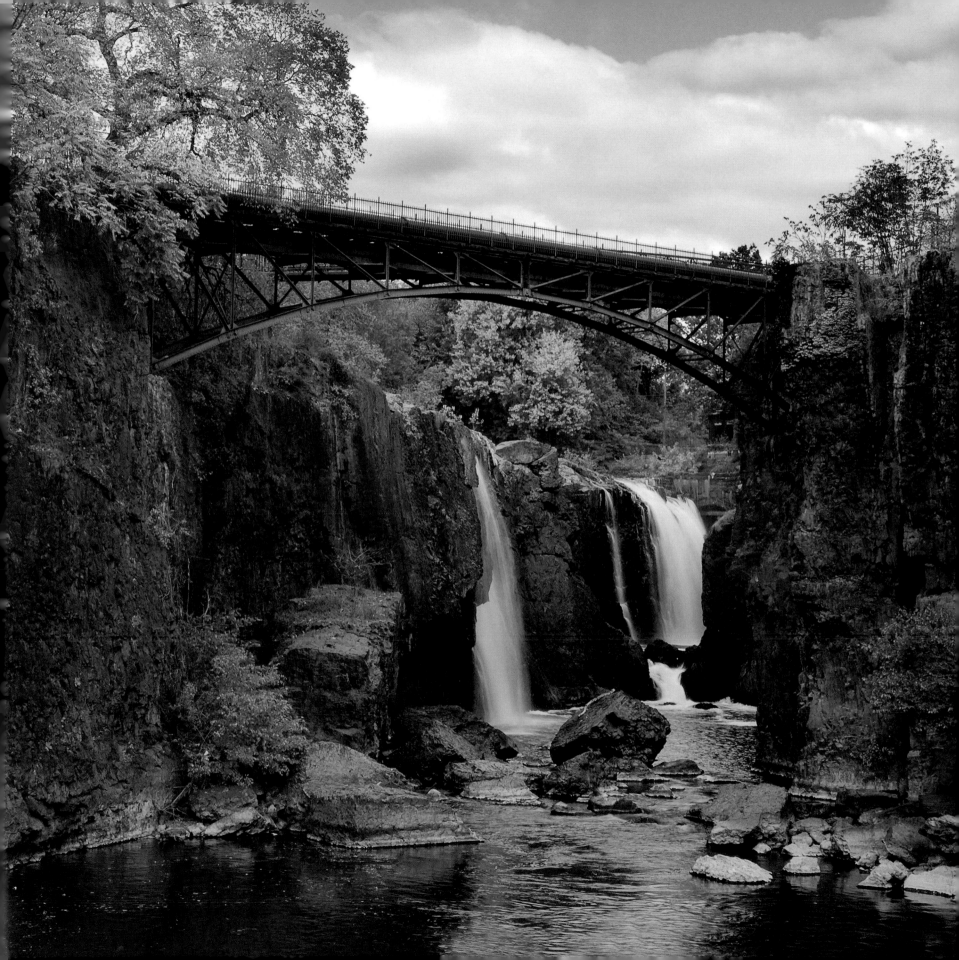

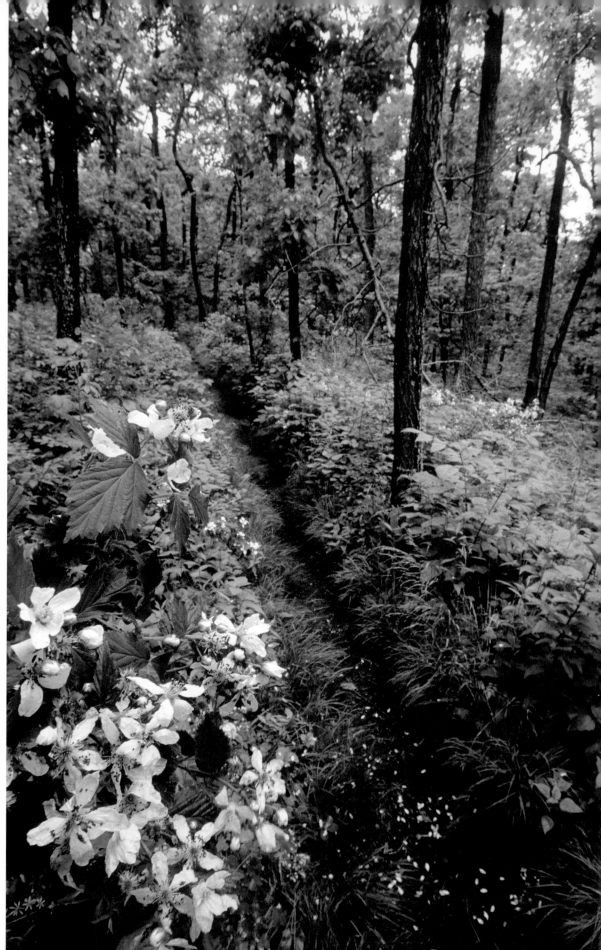

Here the Appalachian Trail wanders through High Point State Park in the northwest corner of the state. With over 50 miles of trails, the park takes visitors through unique and diverse landscapes including mountain ridge tops with 360-degree views, dense forests, fields and wetlands.

OPPOSITE PAGE: In the northwest corner of the state, beautiful woodland trails lead to the aptly named Buttermilk Falls in Stokes State Forest. With its mountain ridges and lush ravines, Stokes is famous for its impressive beauty.

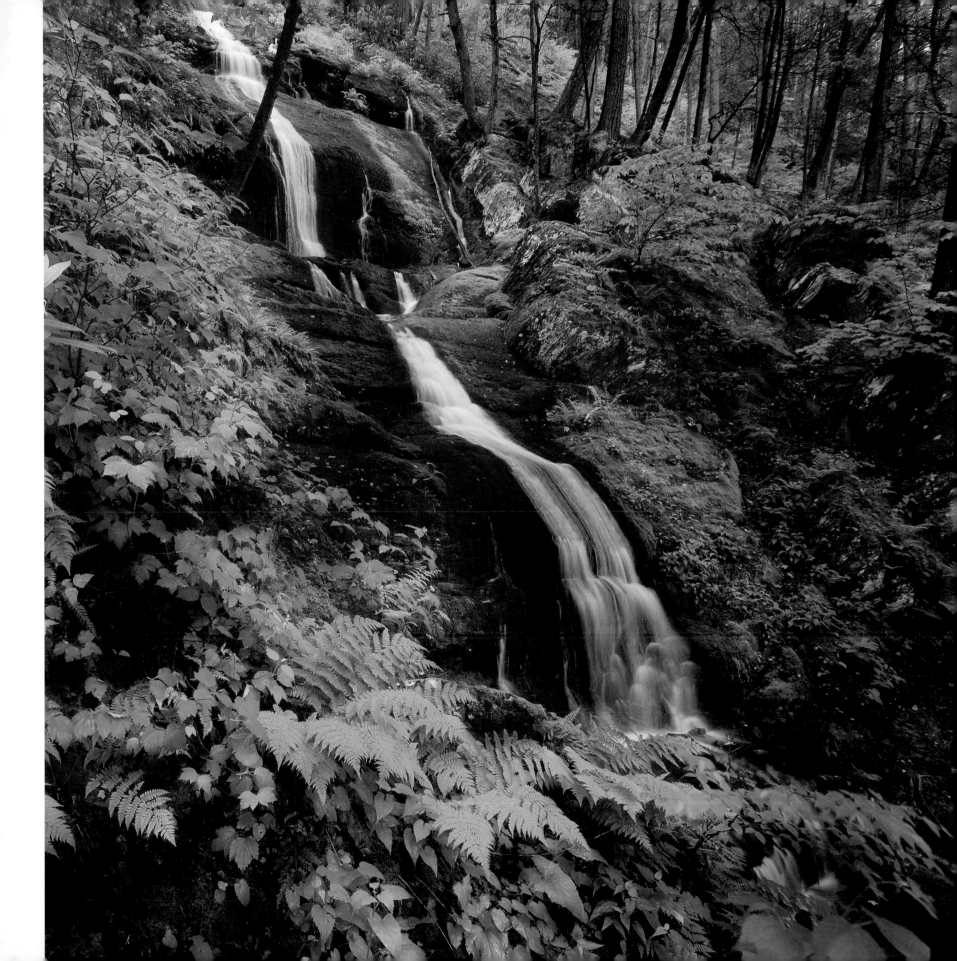

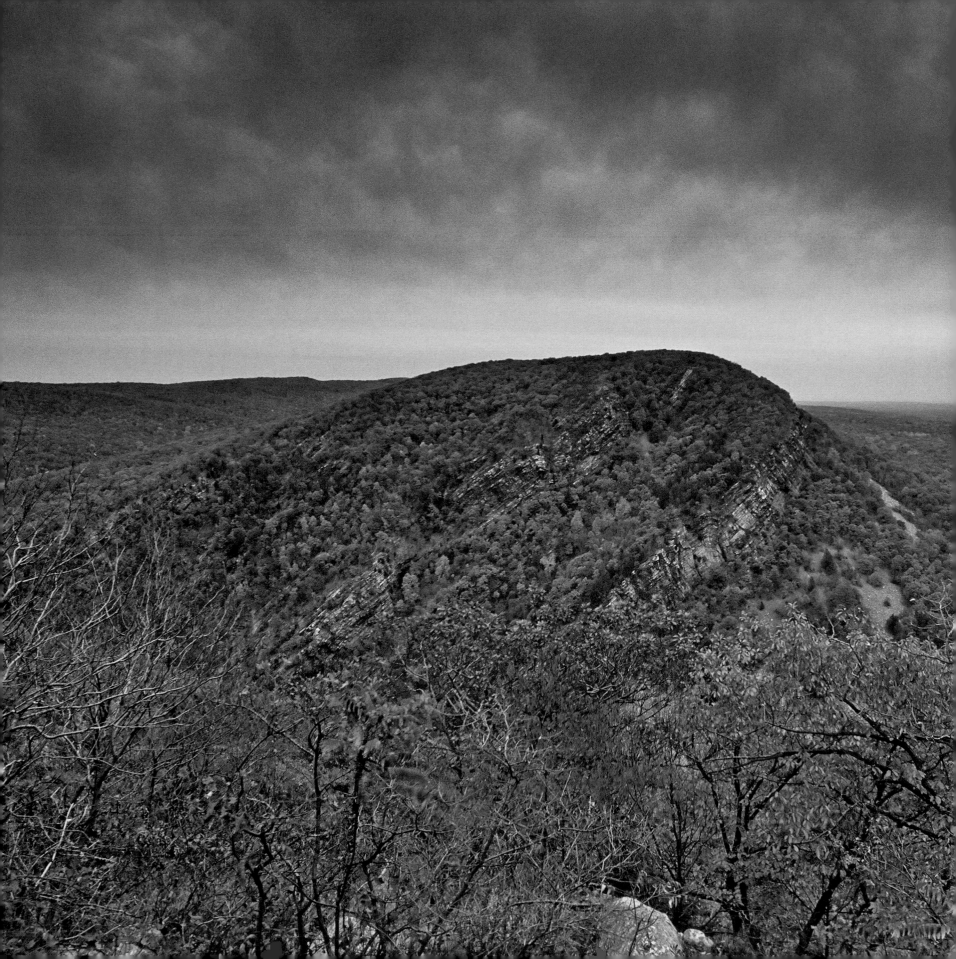

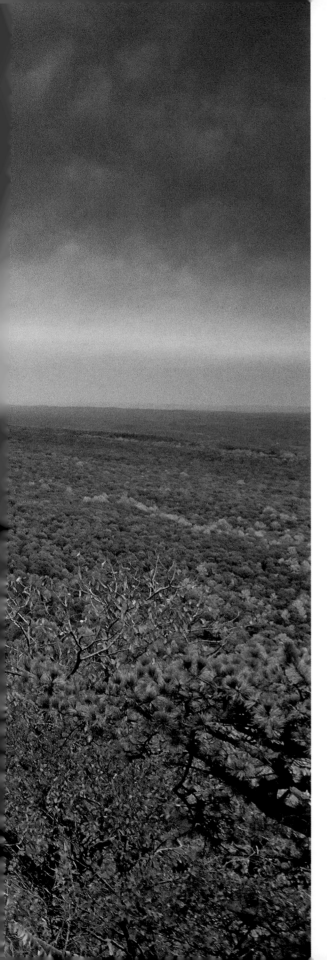

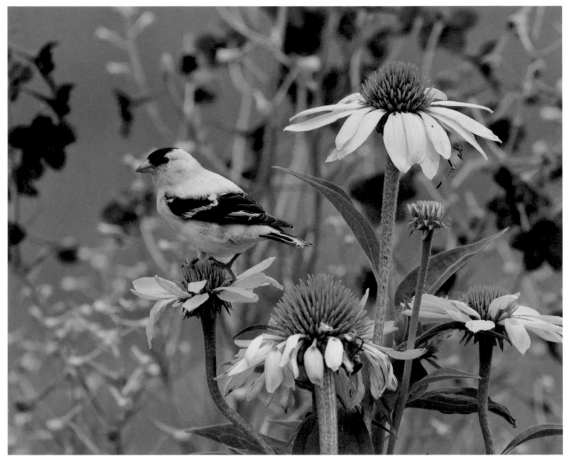

The American Goldfinch is New Jersey's state bird. With its distinctive yellow and black plumage, it can often be seen as a cheerful backyard visitor, even throughout the harsh winter months.

OPPOSITE PAGE: Located in the Worthington State Forest, the demanding trail to the top of Mount Tammany (elevation 1,527 feet) rewards hikers with a spectacular view of the Delaware Water Gap.

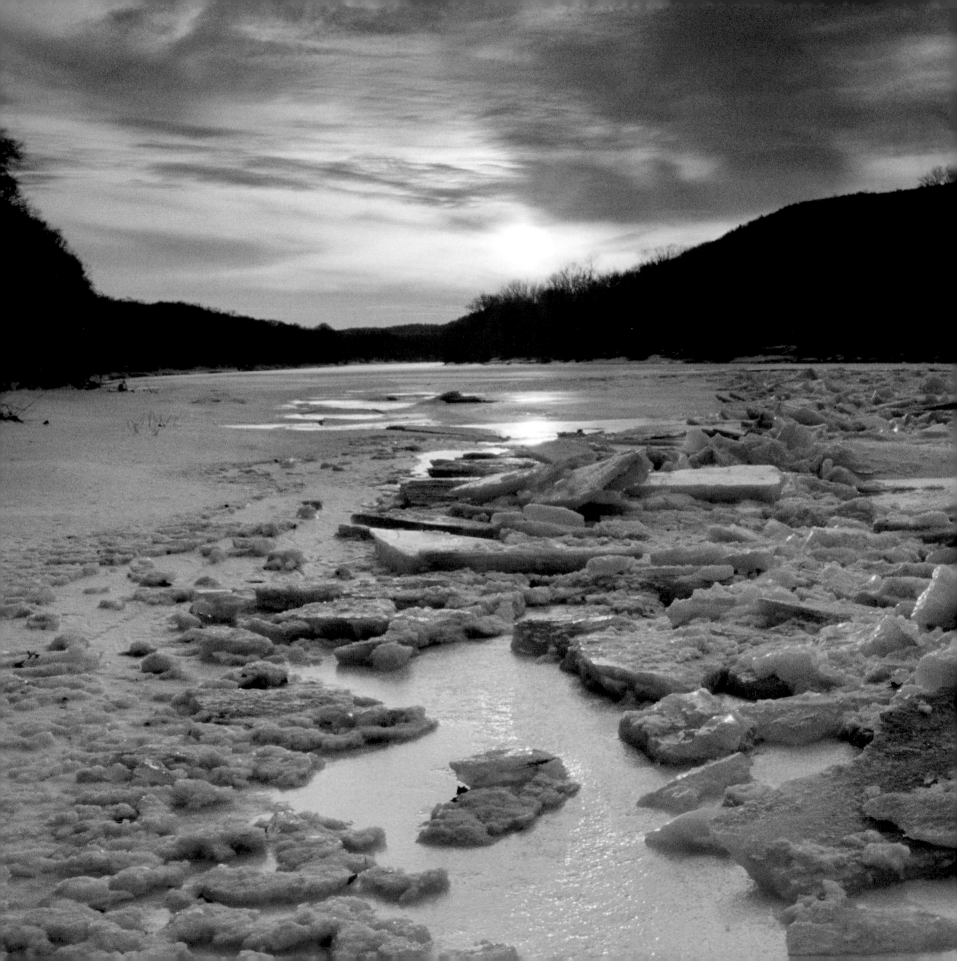

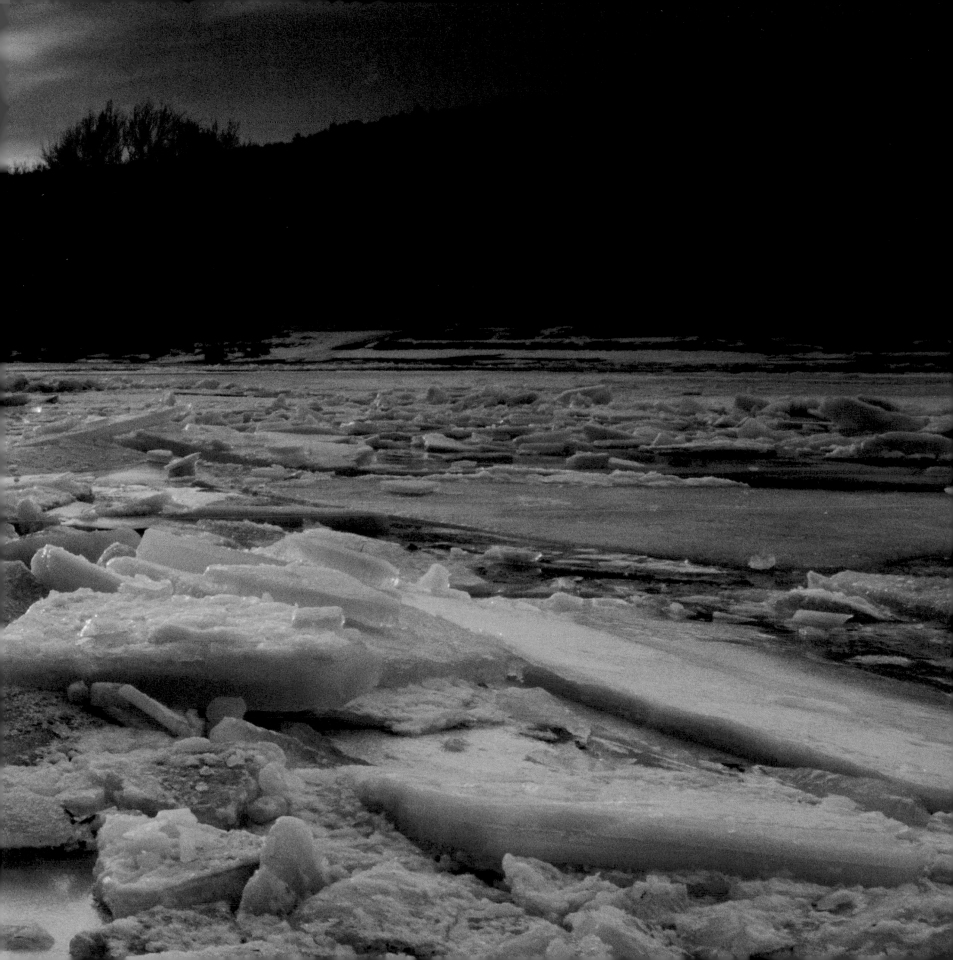

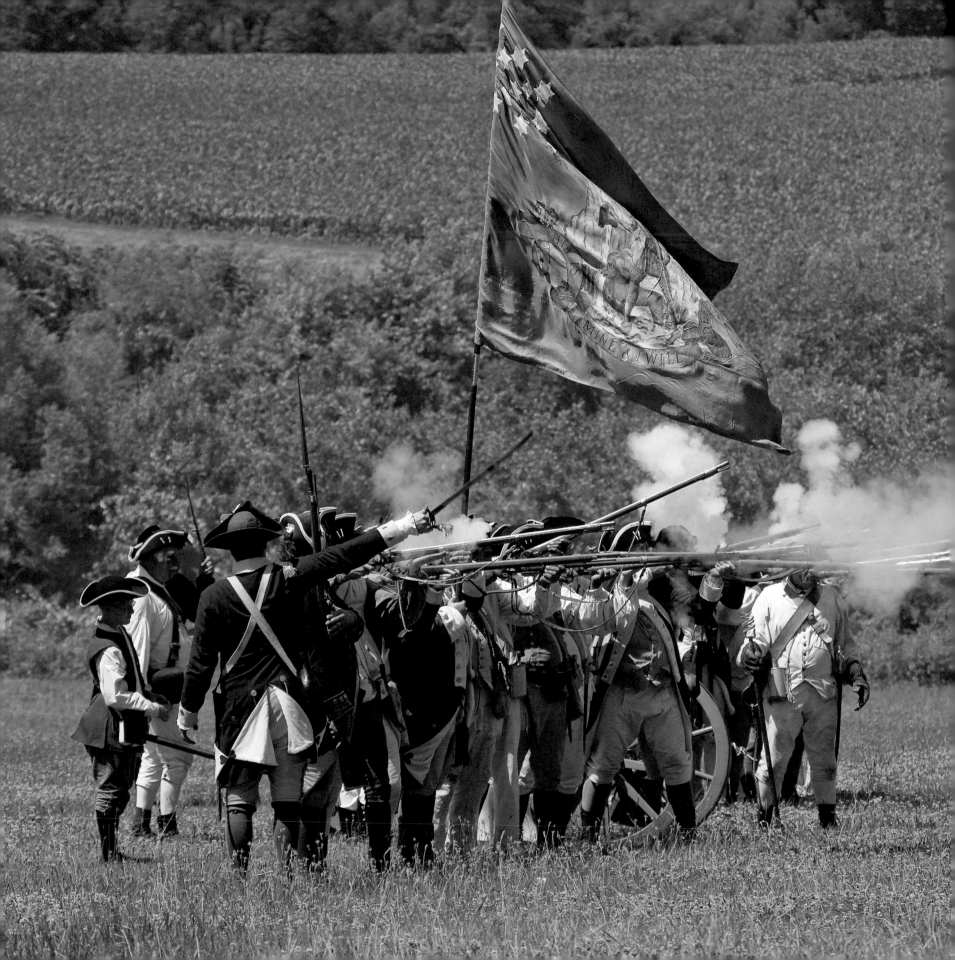

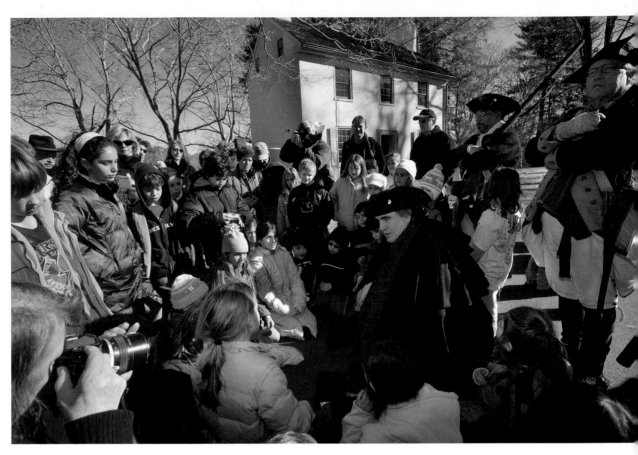

George Washington's young listeners are captivated by a description of the Revolutionary War from the general himself, an actor who offers a living history lesson in Washington Crossing State Park.

OPPOSITE PAGE: Complete with muskets and cannon, Continental Army re-enactors march forward in the Battle of Monmouth each year. This exciting two-day event celebrates the way of life for the soldiers and their families as it was back in 1778 during the American Revolution.

PREVIOUS PAGE: Ice floes create a cold raw beauty as they crowd together in the Delaware River in Worthington State Forest in the northwest region. The forest covers almost 6,000 acres extending about seven miles along the rugged terrain of the Kittatinny Ridge.

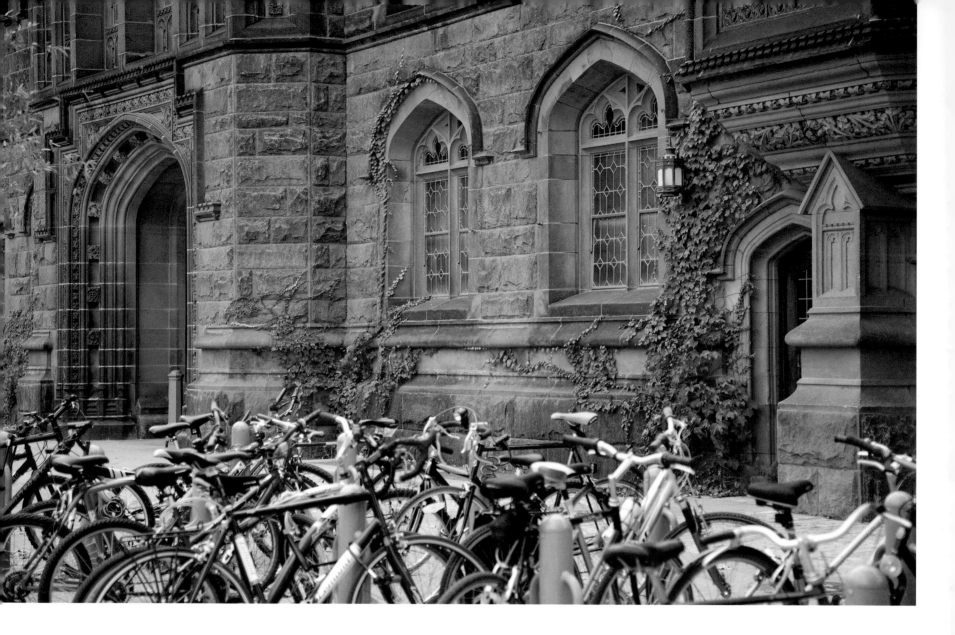

ABOVE: Bicycles wait for the students outside East Pyne Hall at Princeton University.

OPPOSITE PAGE: Princeton is one of the country's most outstanding undergraduate colleges and one of the world's finest research institutions.

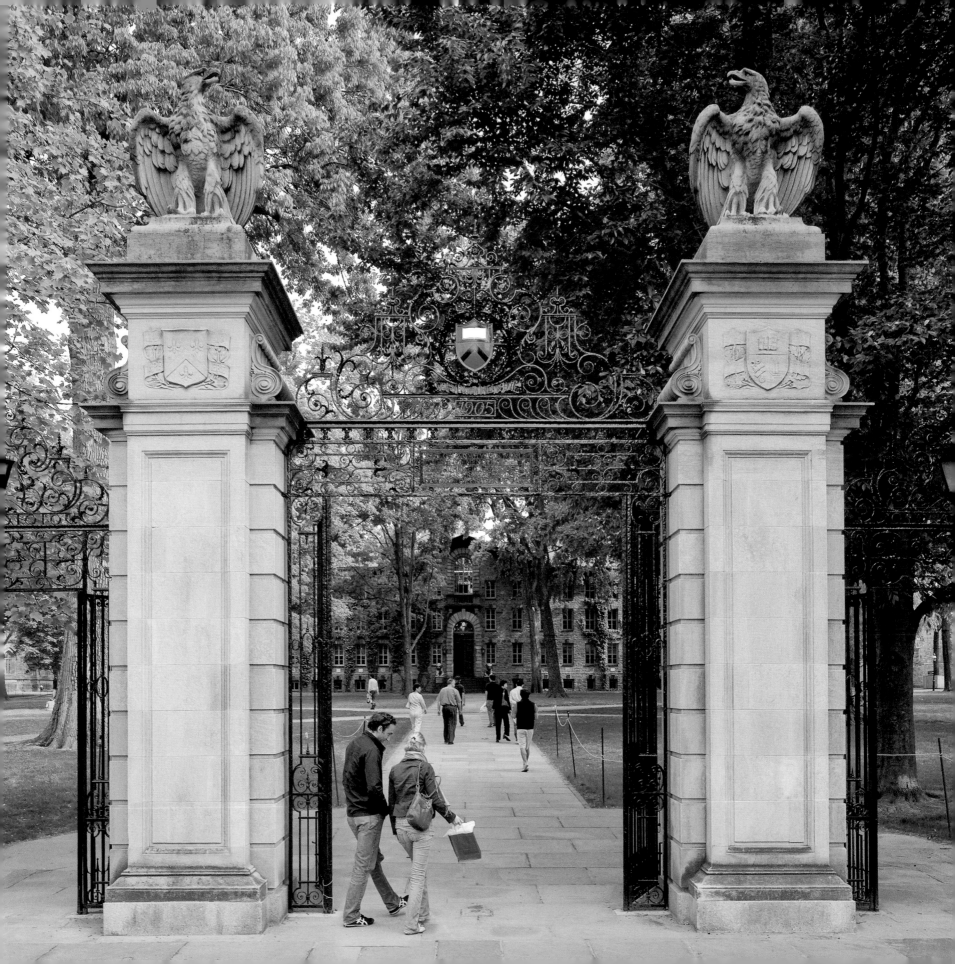

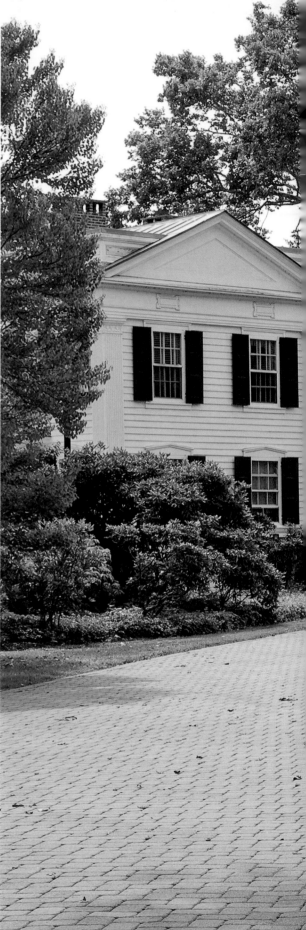

BELOW & OPPOSITE: Drumthwacket is the official residence of the Governor of New Jersey. The home was built in 1835, and the property on which it stands was once owned by William Penn, founder of the colony of Pennsylvania. Located in Princeton, the elegant mansion is close to Trenton, the state capital. Drumthwacket is considered one of the most beautiful executive residences in the country and is open for guided tours on certain days.

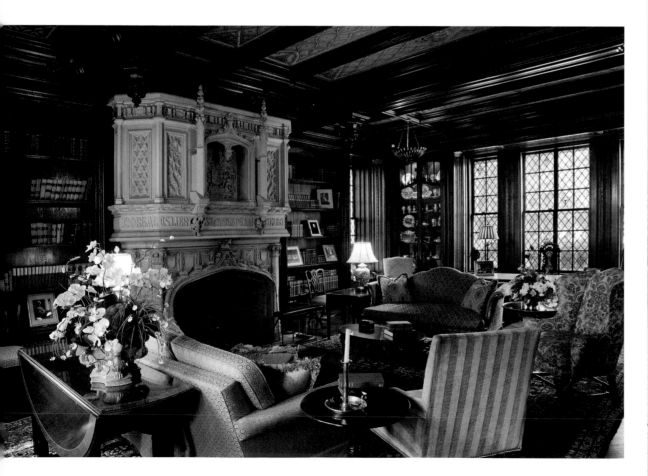

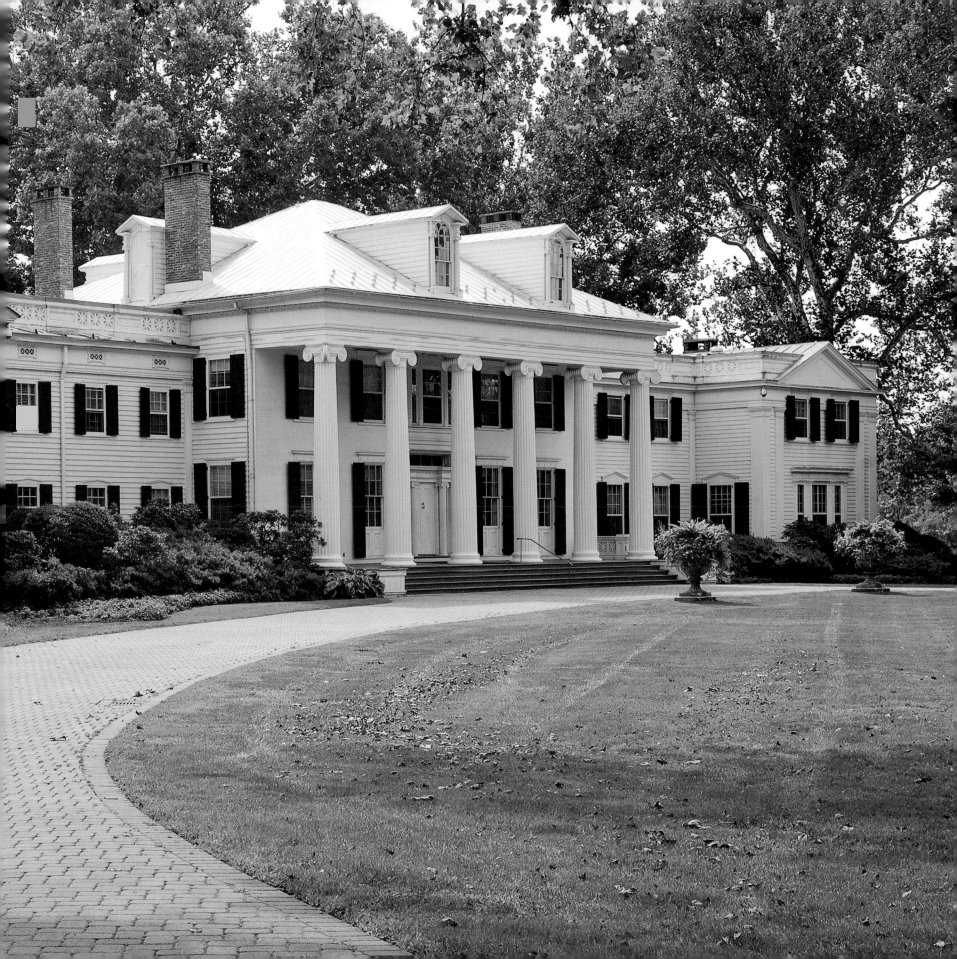

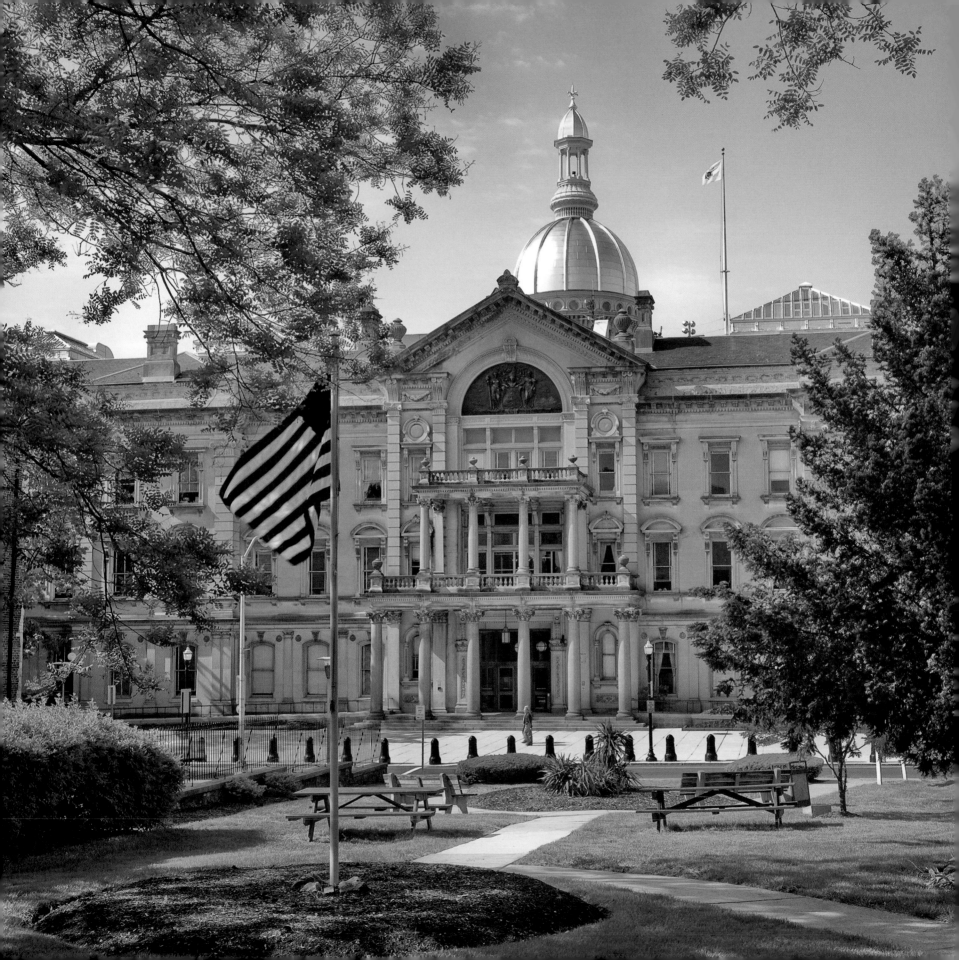

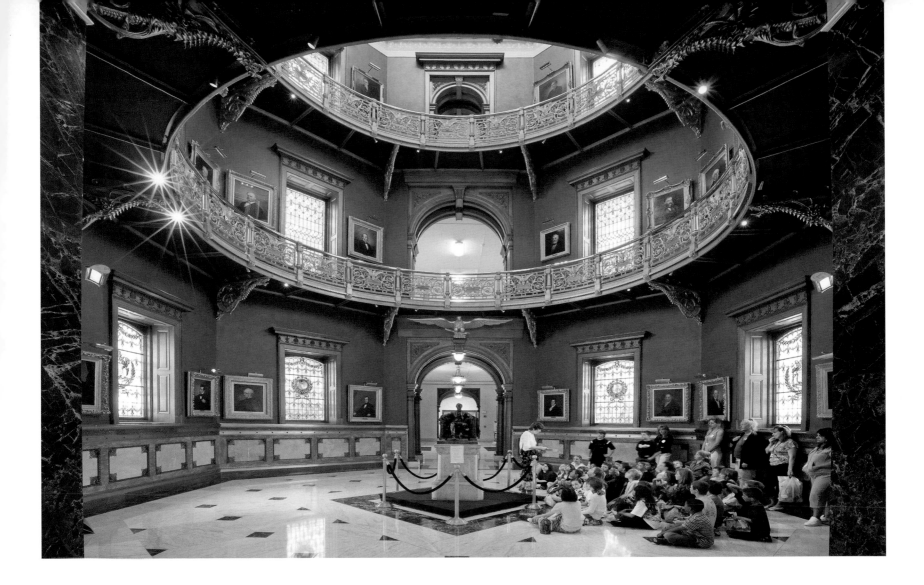

OPPOSITE PAGE: Built in 1792, the New Jersey Legislative State House is an imposing presence in downtown Trenton, capital of the state. A gold dome crowns the building.

ABOVE: The inner rotunda is a magnificent example of 18th-century elegance. For more than 200 years, the laws of the state have been made in this building.

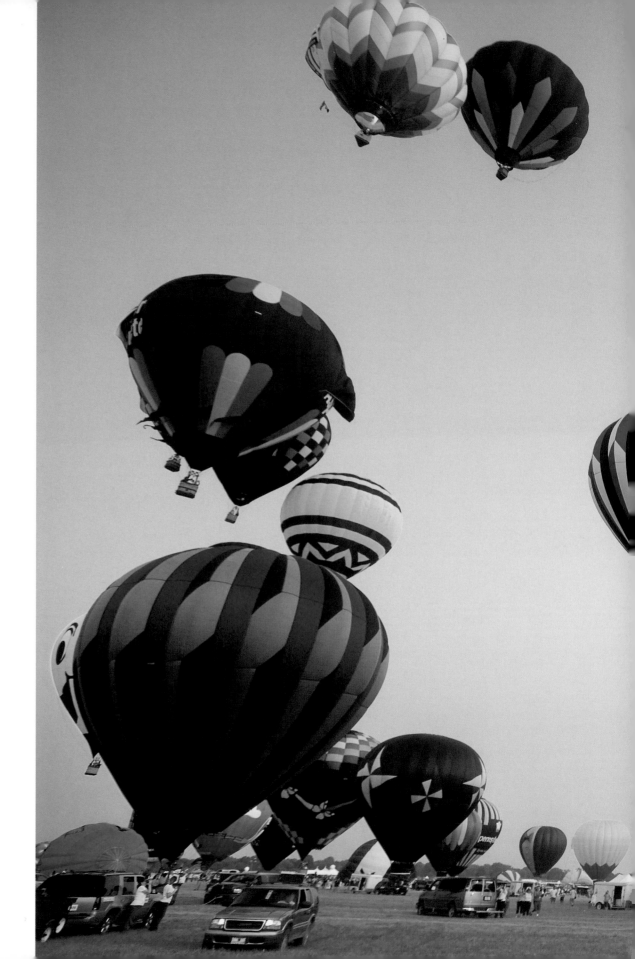

The Quick Chek Festival of Ballooning is the largest summertime hot air balloon and music festival in North America. Held annually at Solberg Airport in Readington, in central New Jersey, this festival has something for everyone.

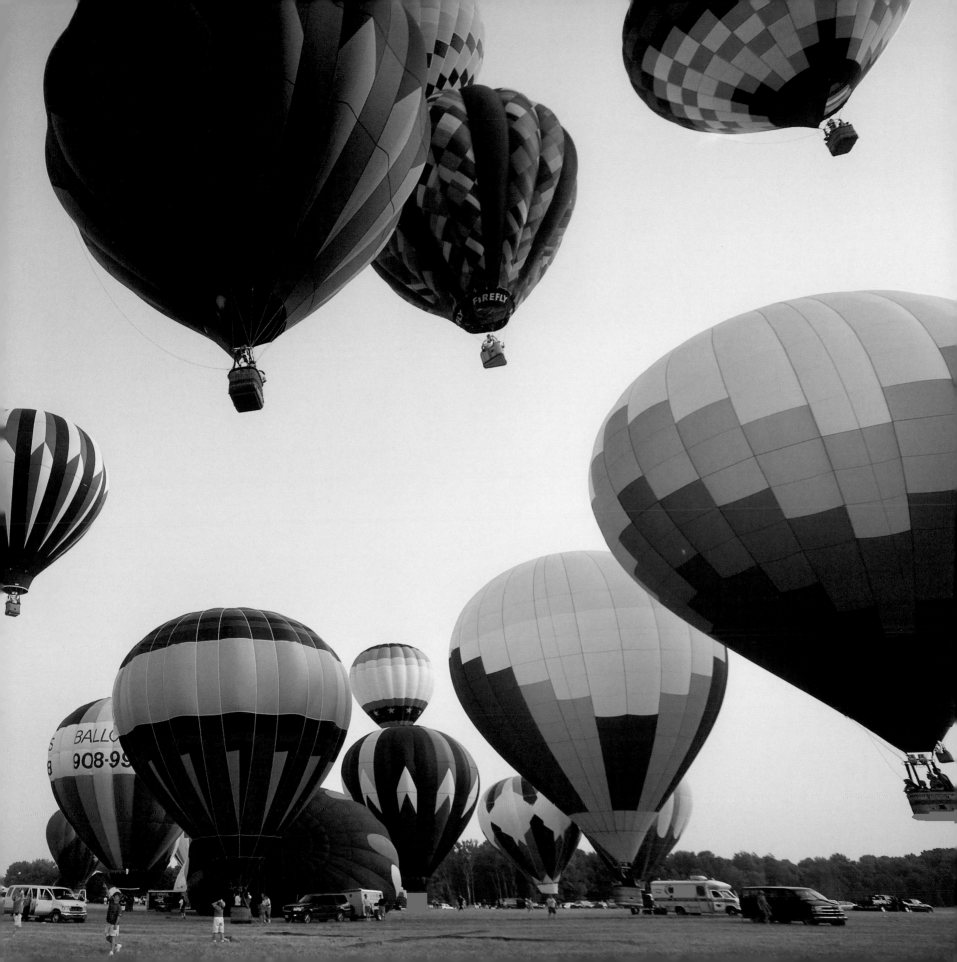

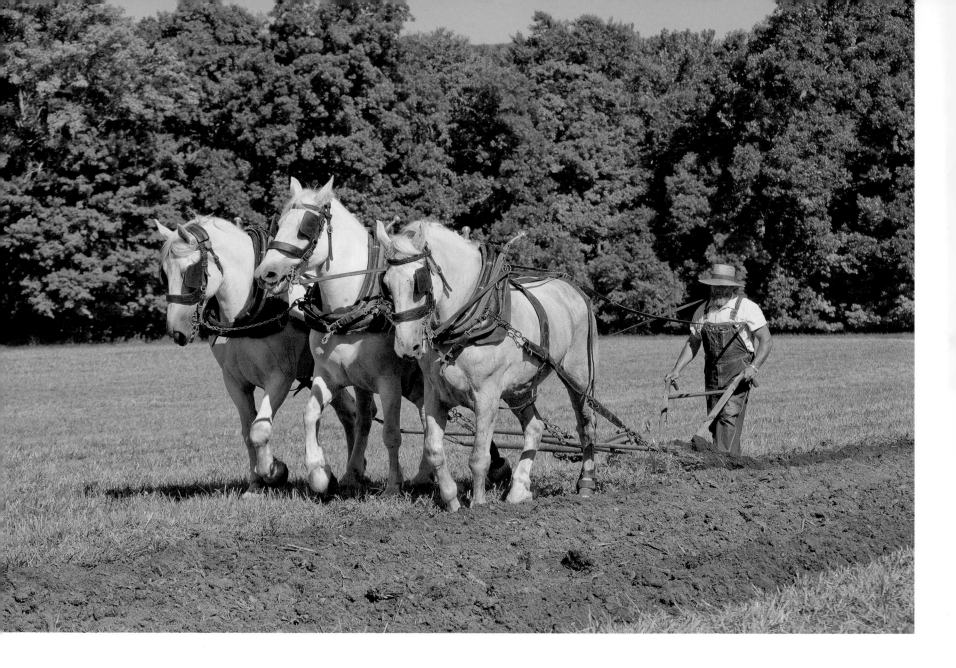

The Howell Living History Farm, in its rural setting of Mercer County in the center of the state, shows how farming was practiced in the period of 1890–1910. Barn dances, hay wagon rides, maple sugaring and open-hearth cooking are just a few of the experiences offered.

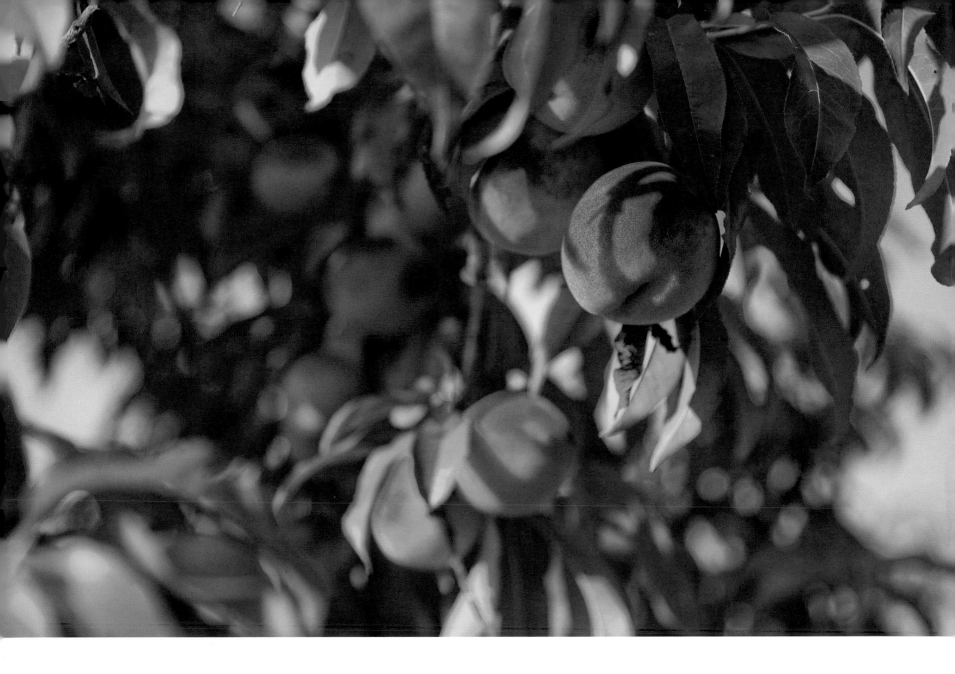

New Jersey is known for its excellent produce, including blueberries, tomatoes, corn and cranberries. Its peaches are sweet and juicy, and the state ranks fourth in the nation in production of that fruit.

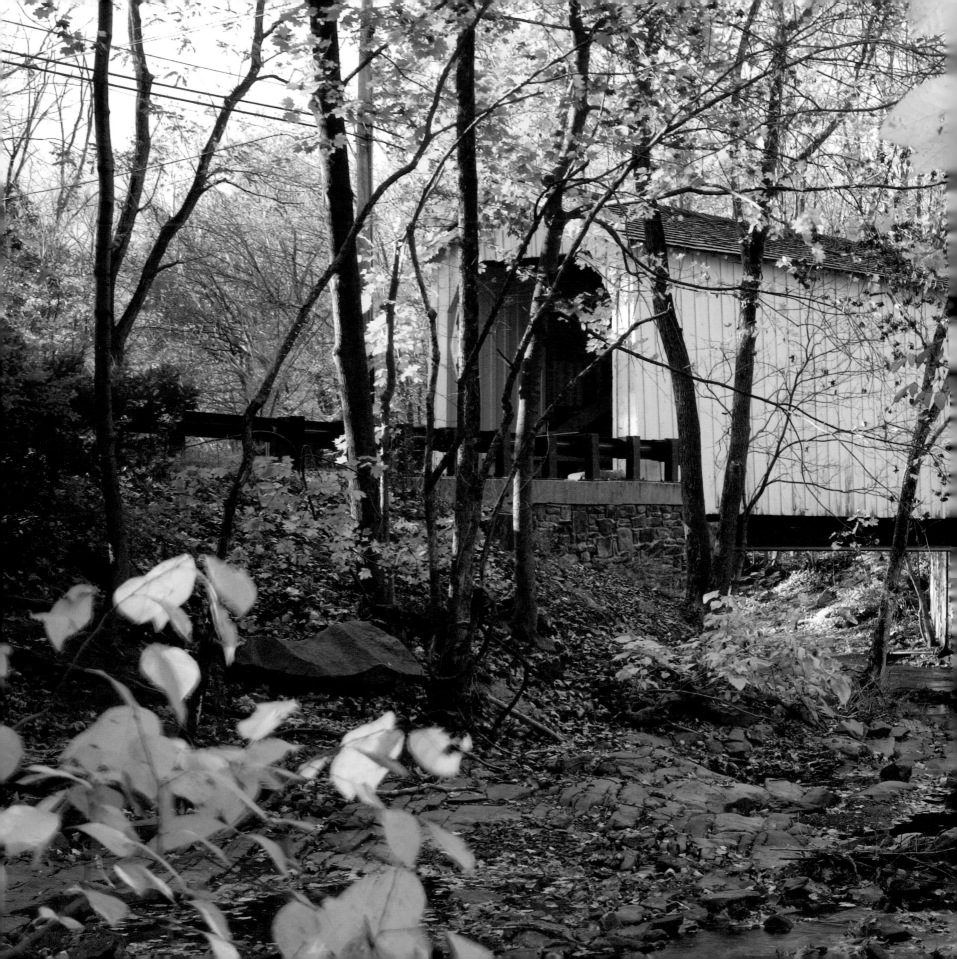

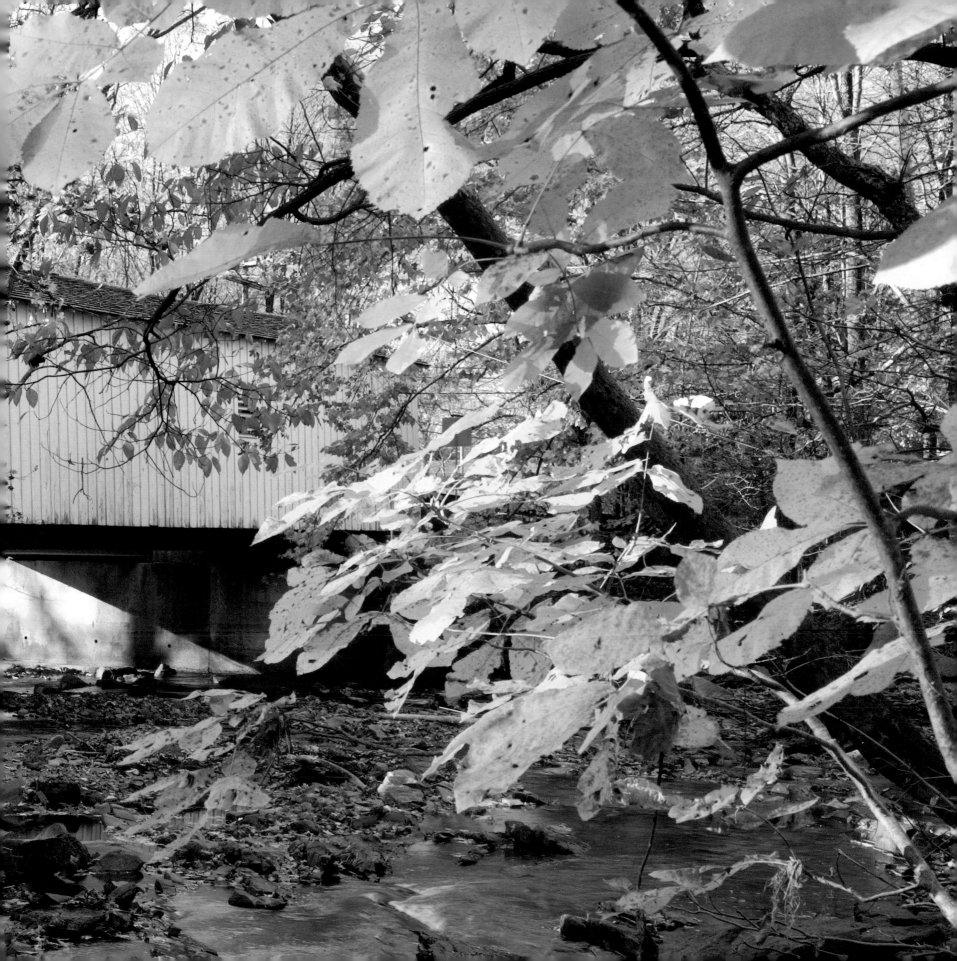

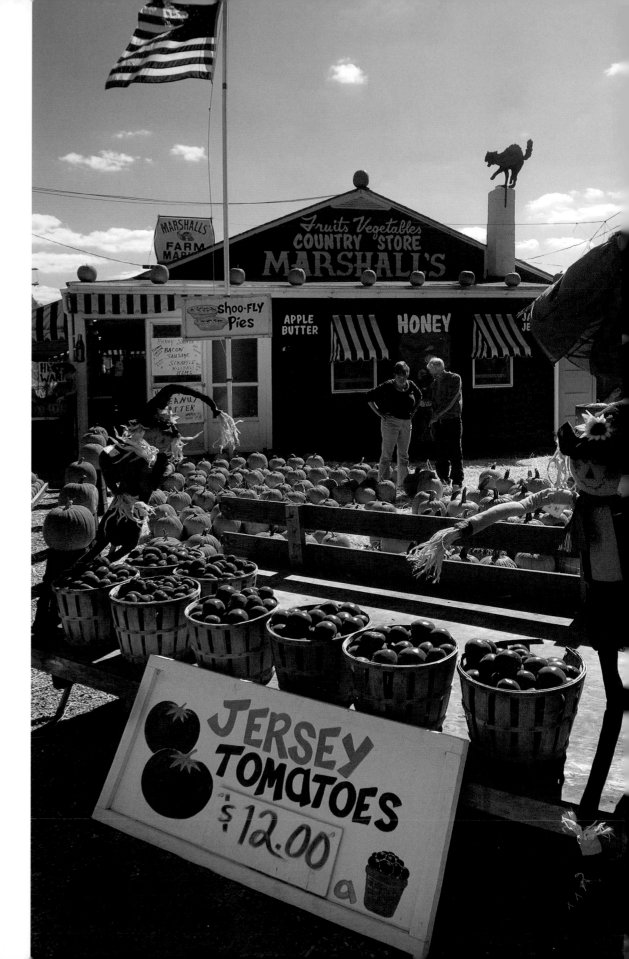

Hunterdon County has been a rich agricultural center from the early 1700s. Roadside farmer's markets with freshly picked produce easily tempt visitors along the route.

PREVIOUS PAGE: There are more than two thousand bridges in New Jersey, but Green Sergeant's is the only *historic* covered bridge in the state. It is 84 feet long and was built in 1866 near Flemington.

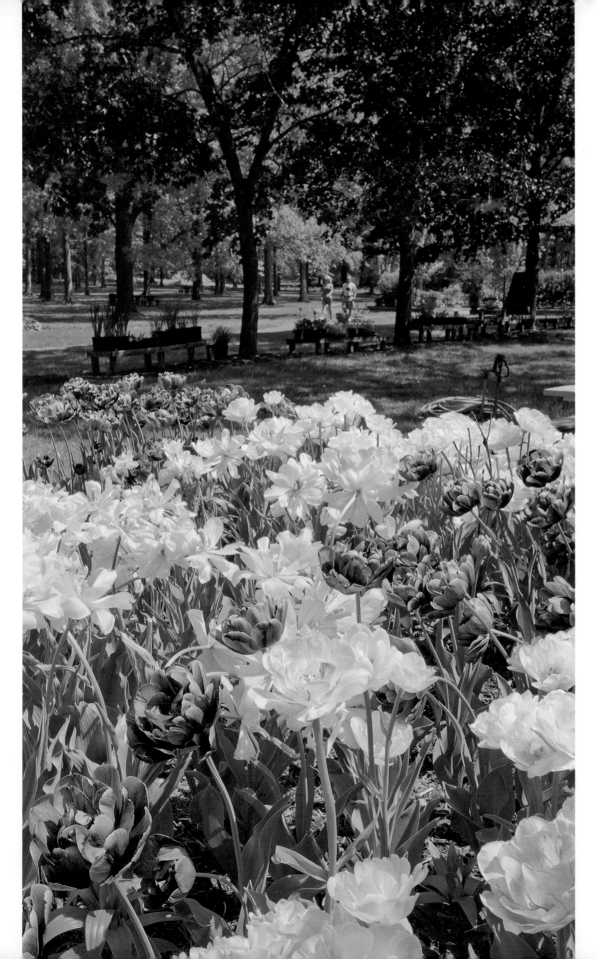

Spring flowers celebrate the coming of warmer weather in the beautiful Hunterdon County Arboretum. This 73-acre arboretum is also the headquarters of Hunterdon County's extensive park system, where visitors can find species of distinctive trees and shrubs, plus native and exotic plants.

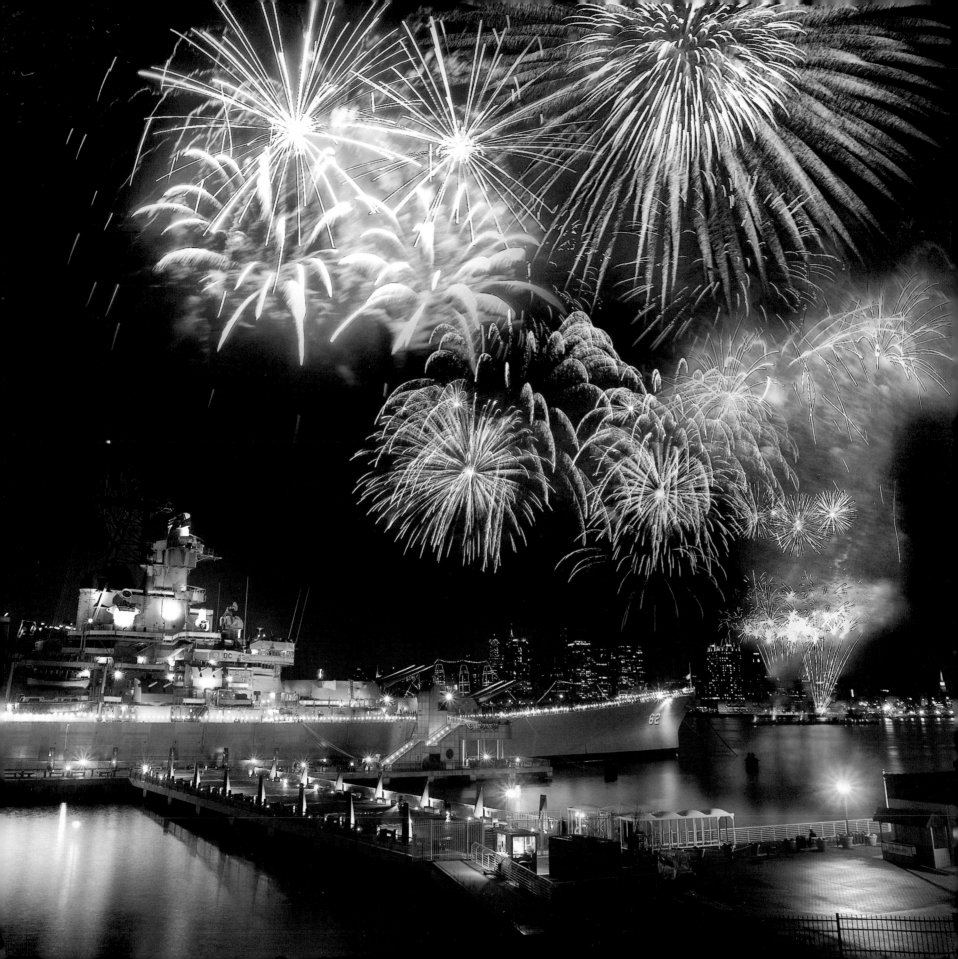

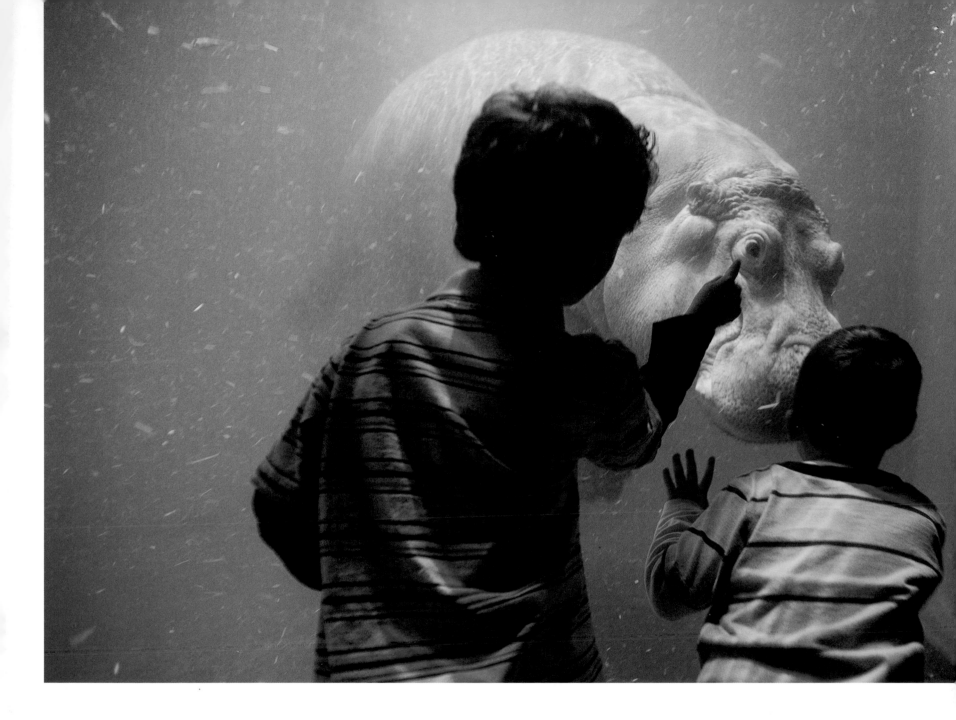

ABOVE: Children interact with a hippopotamus at the Adventure Aquarium on the Camden Waterfront. Located along the scenic Delaware River, the area has many attractions and is just across from Philadelphia's historic district, offering a unique two-sided waterfront destination.

OPPOSITE PAGE: New Year's fireworks explode over the USS *New Jersey,* America's most decorated battleship. Having served in the Second World War, Korea, Vietnam and the Persian Gulf, it is now an exciting museum on the Camden waterfront on the Delaware River.

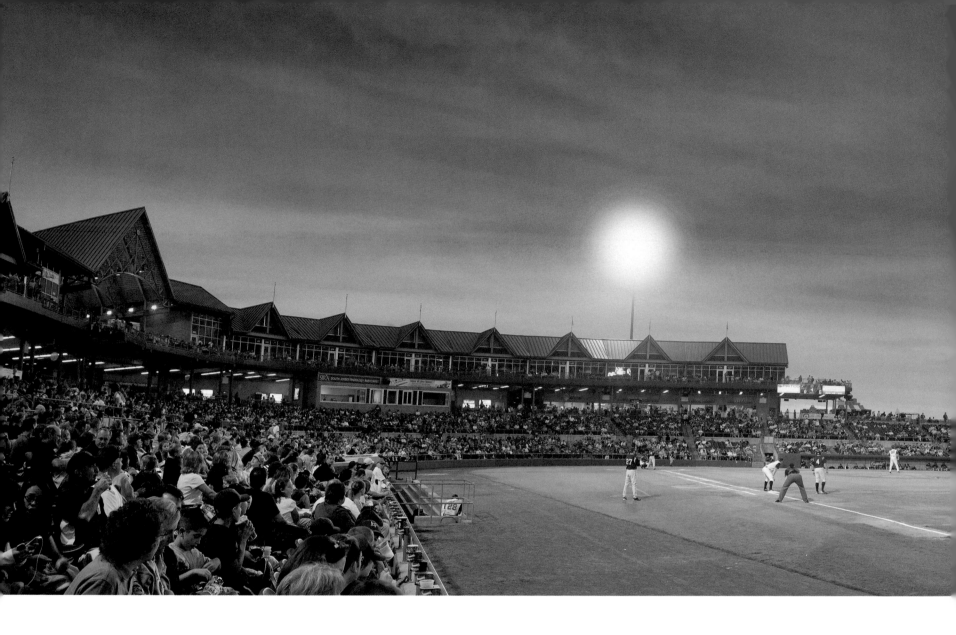

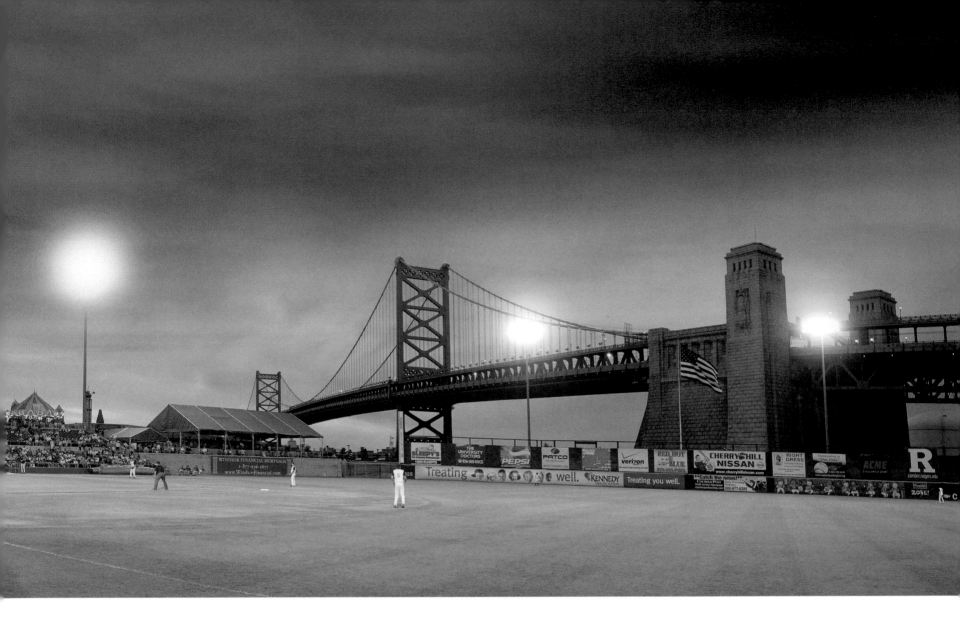

The crowd fills Campbell Stadium in Camden to cheer for South Jersey's home team – the Camden Riversharks, a member of the Atlantic League of Professional Baseball.

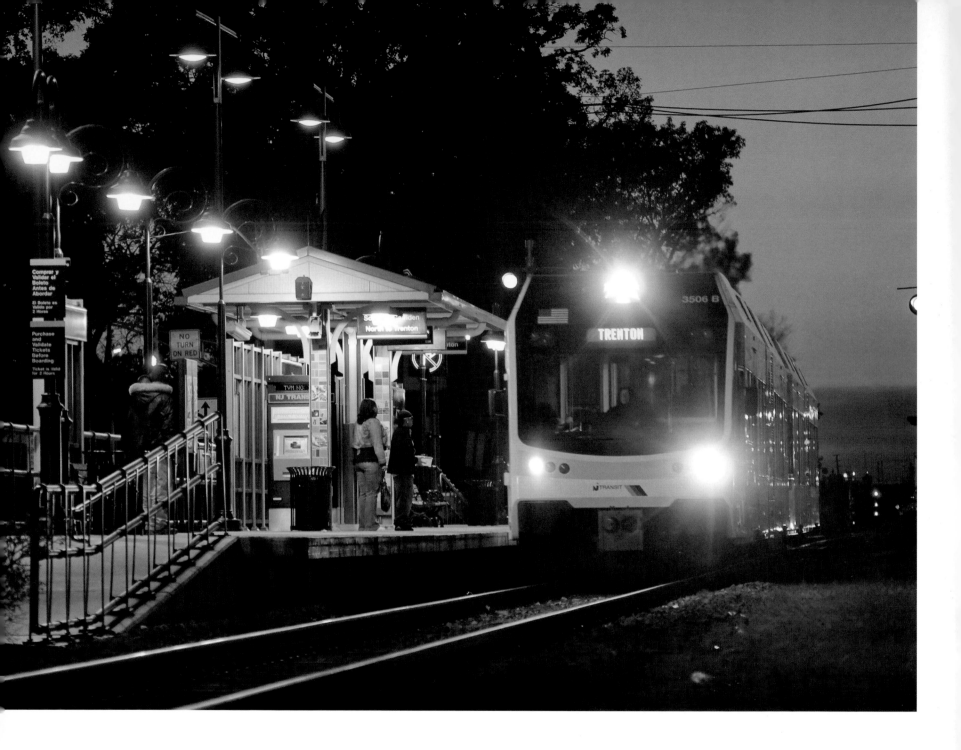

The River Line was the first light rail system to operate in the United States. Northbound passengers at the Palmyra station head to Trenton, where they can make connections to New York City or Philadelphia.

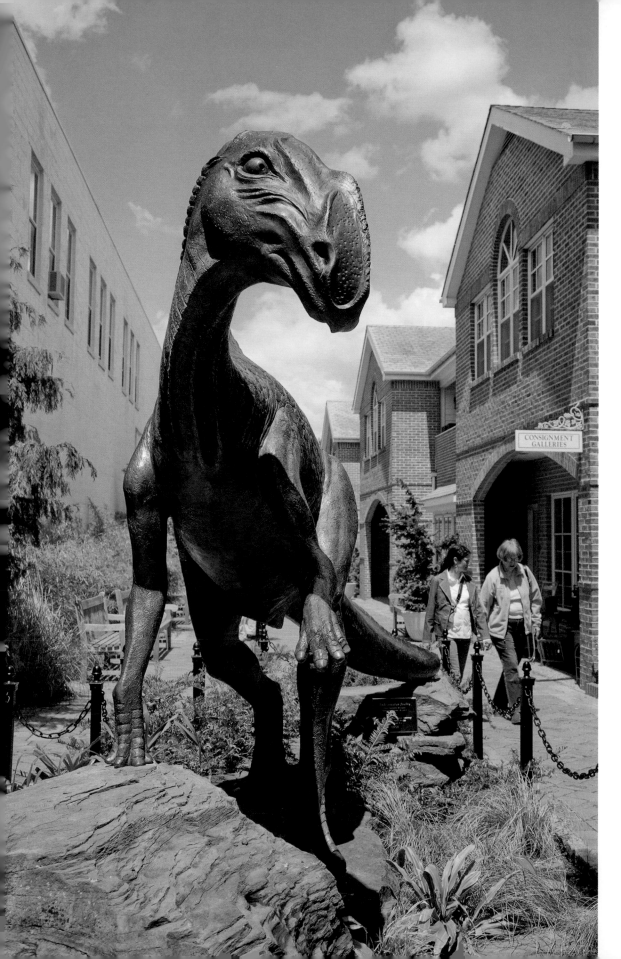

Haddonfield is the location of one of the world's most significant paleontology sites. In 1858, the first nearly complete skeleton of a dinosaur was discovered here. The Hadrosaurus, honored by an eight-foot-tall bronze sculpture, is the state fossil of New Jersey.

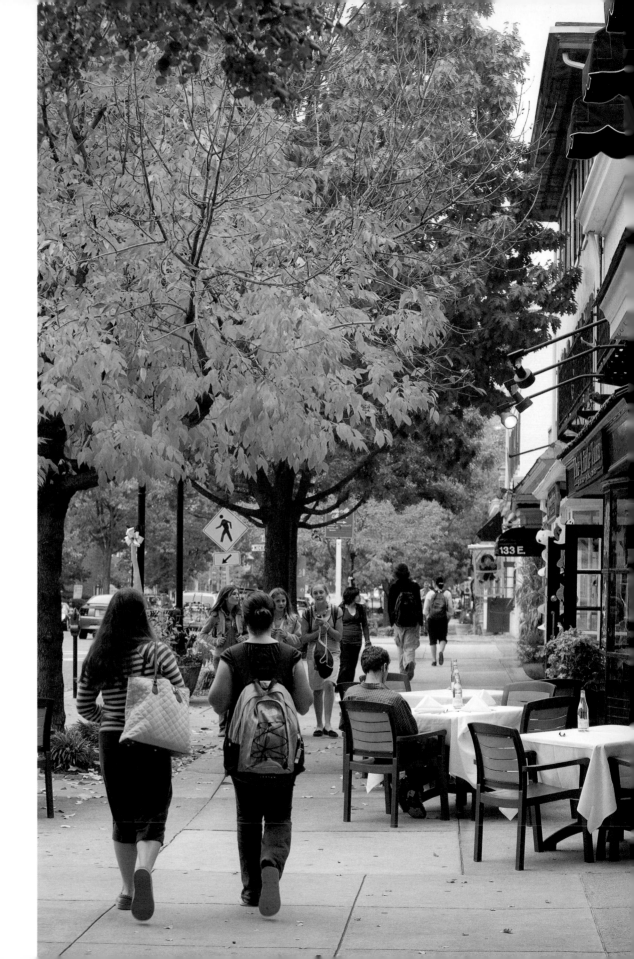

Haddonfield is known not only for its dinosaur discovery, but also for its quaint shops and historic homes.

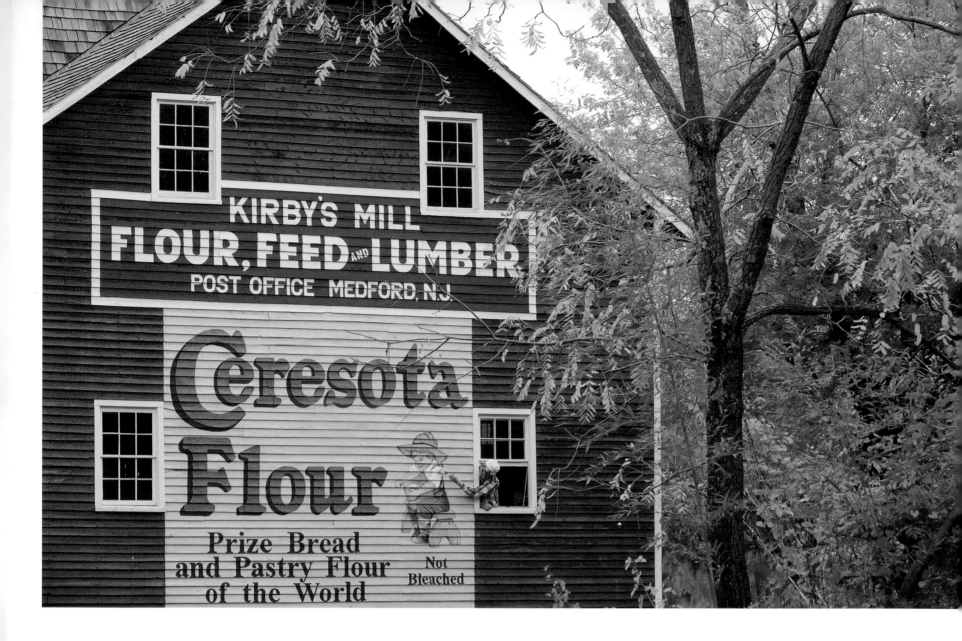

Kirby's Mill in Medford has been entered into the National Register of Historic Places.
The town, considered a suburb of Philadelphia, played a role in the American Revolution.

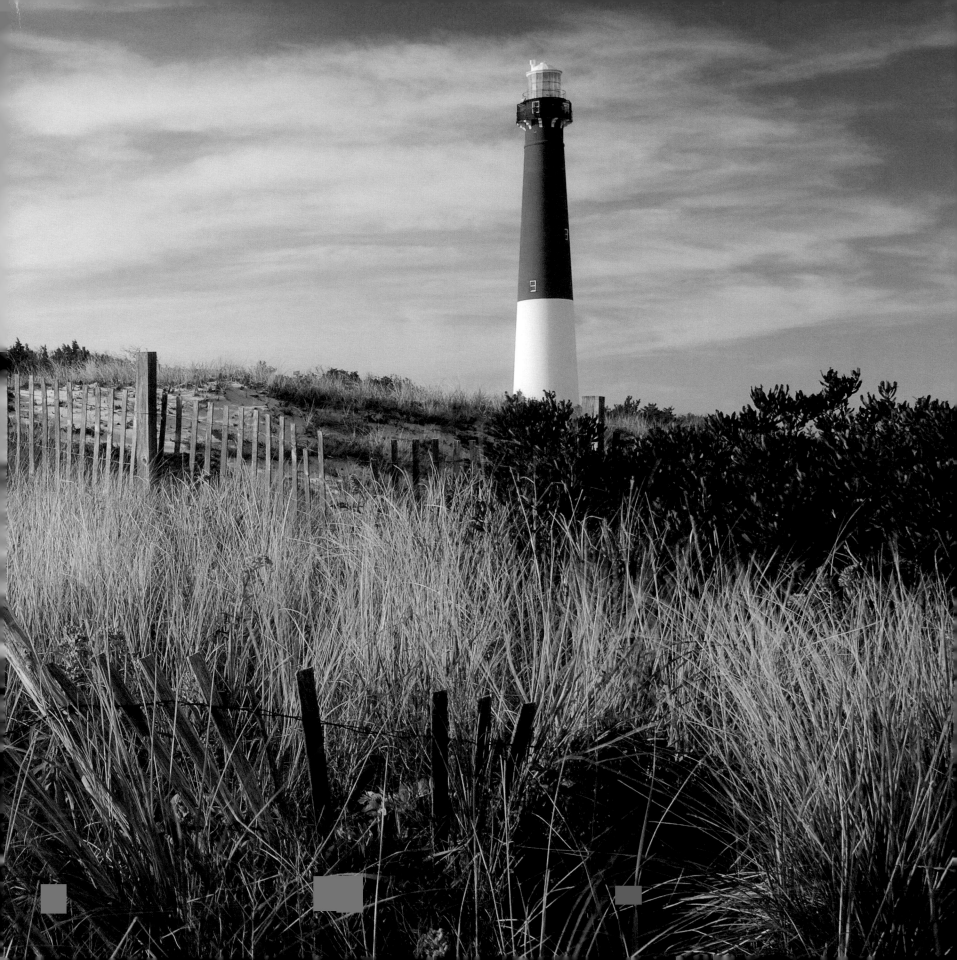

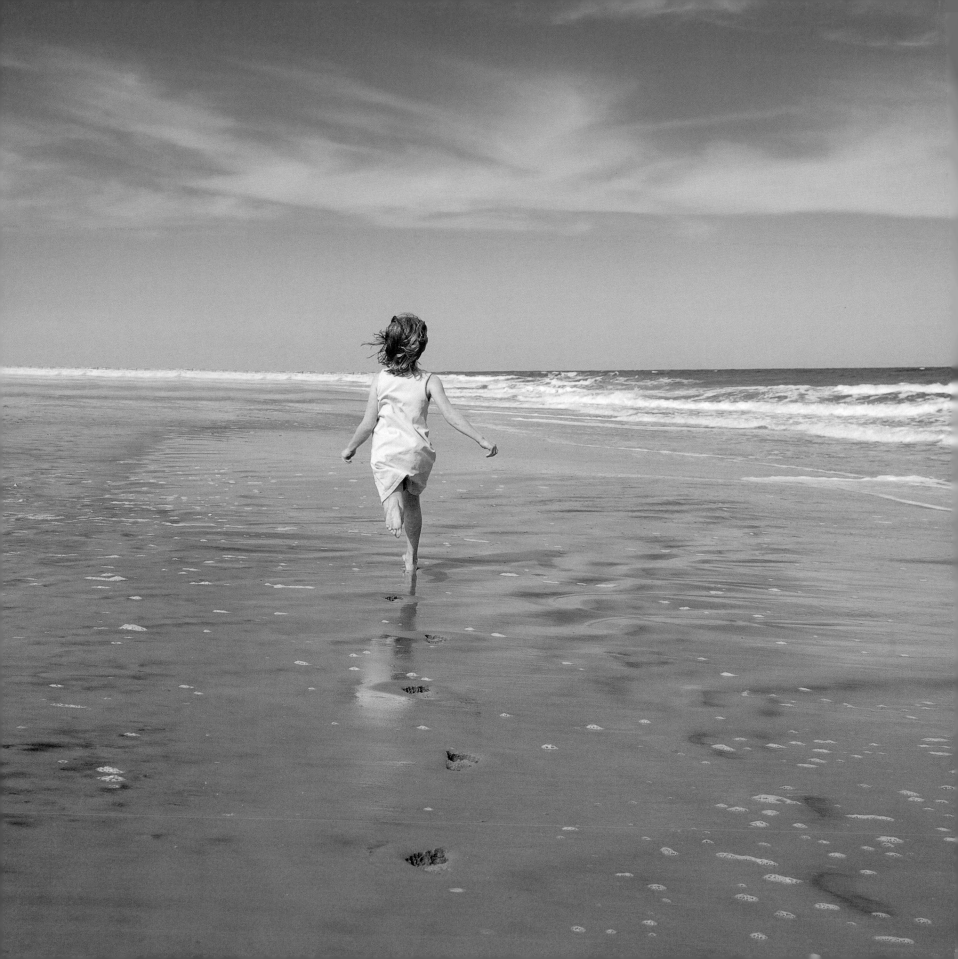

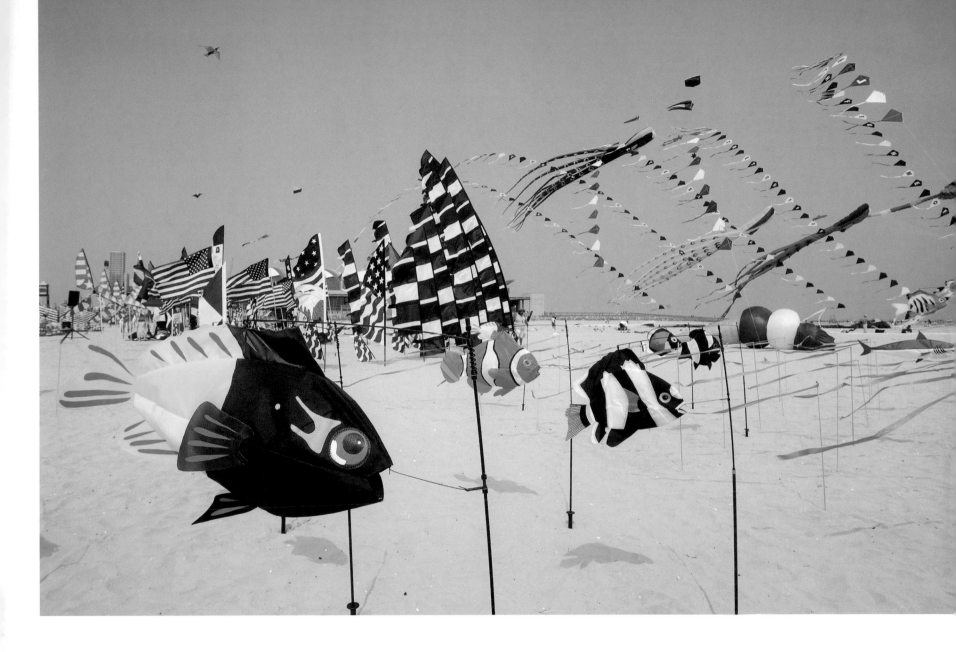

On this five-mile-long family-friendly island just north of Cape May, Wildwood hosts an annual kite festival that paints the long sandy beaches with a riot of colors and shapes.

OPPOSITE PAGE: The joys of the New Jersey coast!

PREVIOUS PAGE: The Barnegat Lighthouse, built in 1834 and rebuilt in 1857, still commands a fine view at the north end of Long Beach Island halfway down the Atlantic coast of New Jersey. The town itself has become a well-known art colony, and fishing is still a popular summertime diversion.

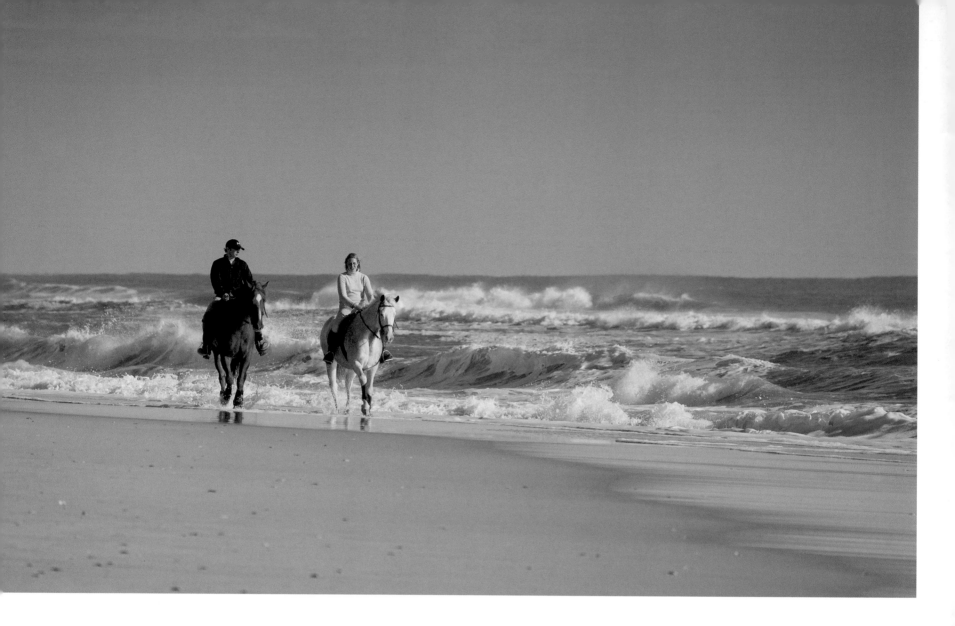

Island Beach, just south Seaside Park, boasts 10 idyllic miles of clean sand and surf. The park, which welcomes more than a million visitors a year, opened in 1959.

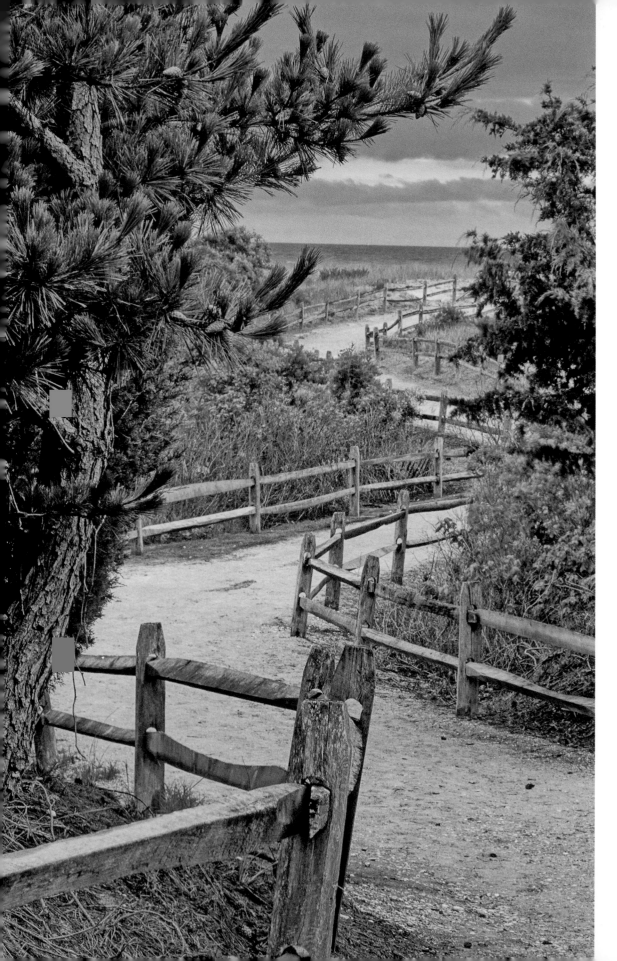

An inviting path leads the visitor through the coastal sand dunes to the undeveloped miles of pristine beaches that line Cape May near Avalon.

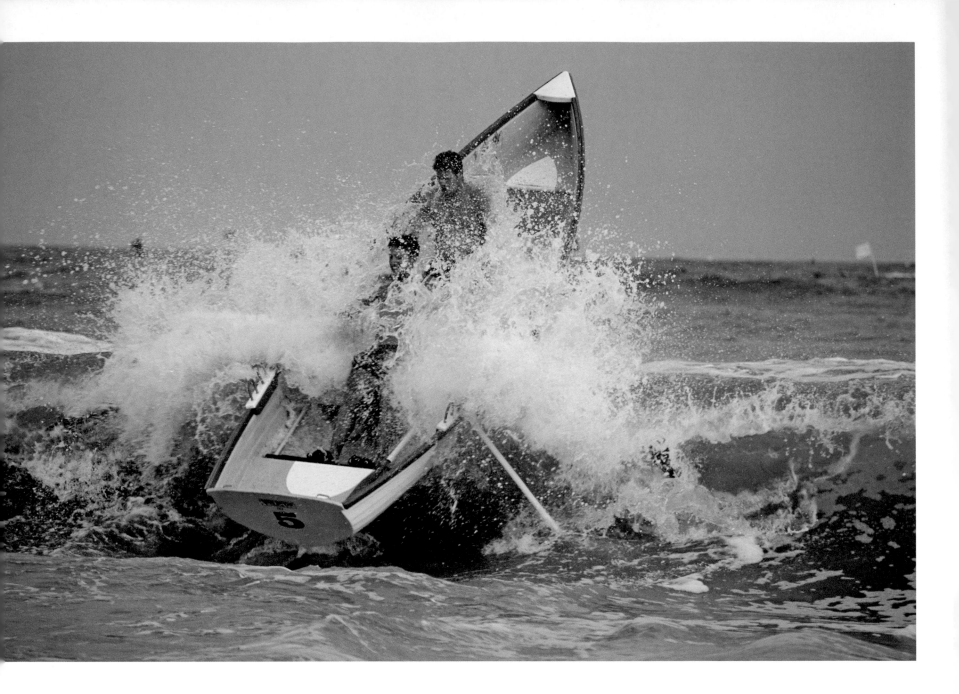

Lifeguards are on duty with their rescue boat in the powerful surf of the Atlantic Ocean. Experienced surfers love these rough and often dangerous waters.

OPPOSITE PAGE: Shortboard surfing is another favorite sport on the eastern seaboard.

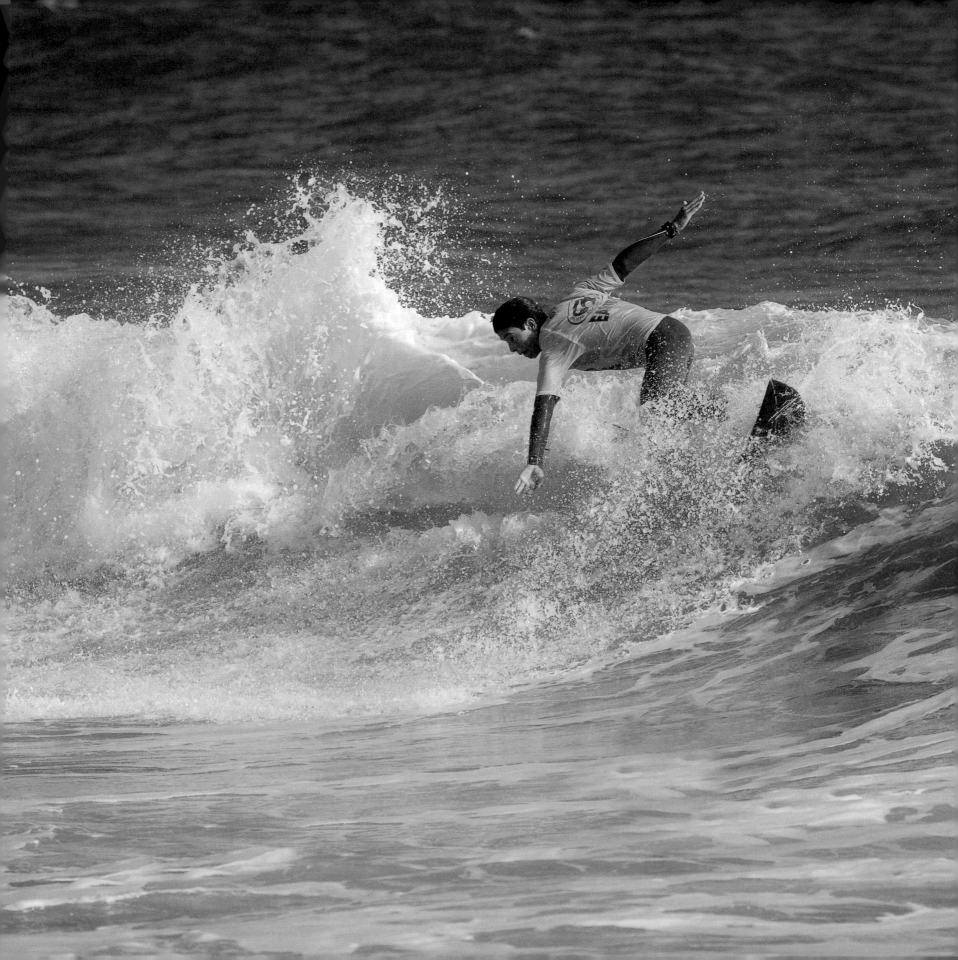

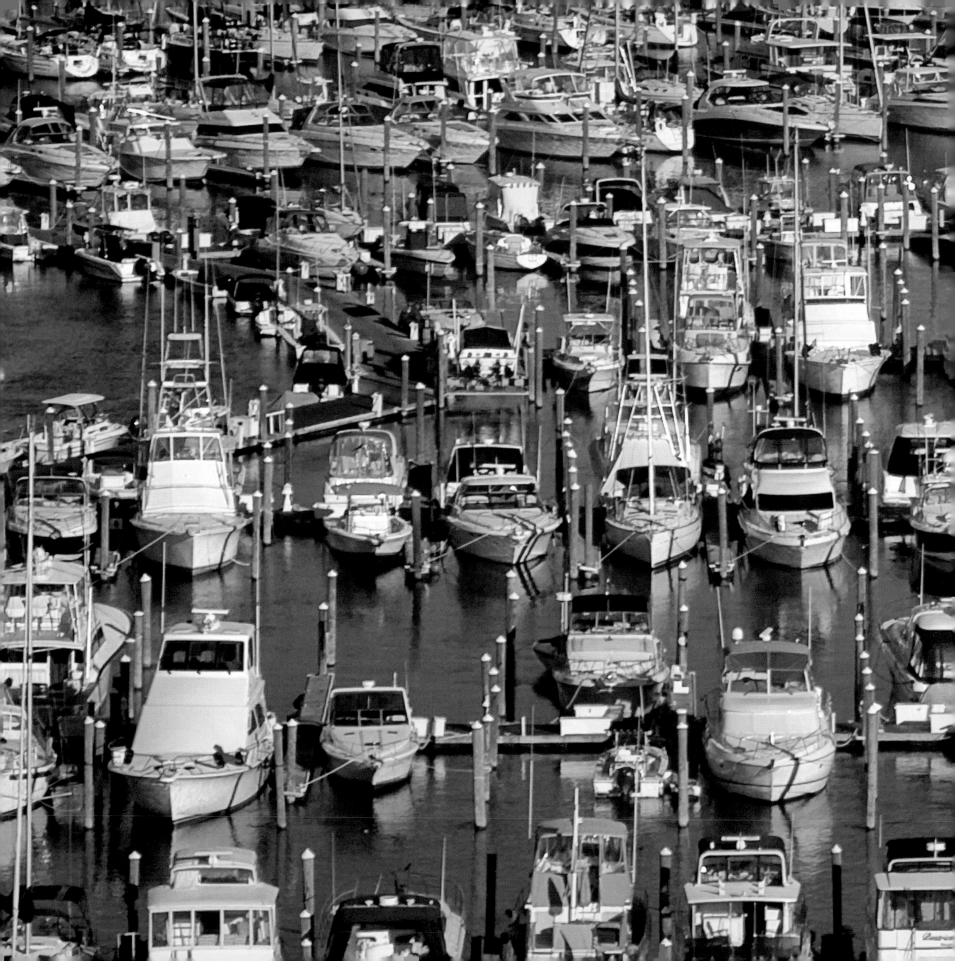

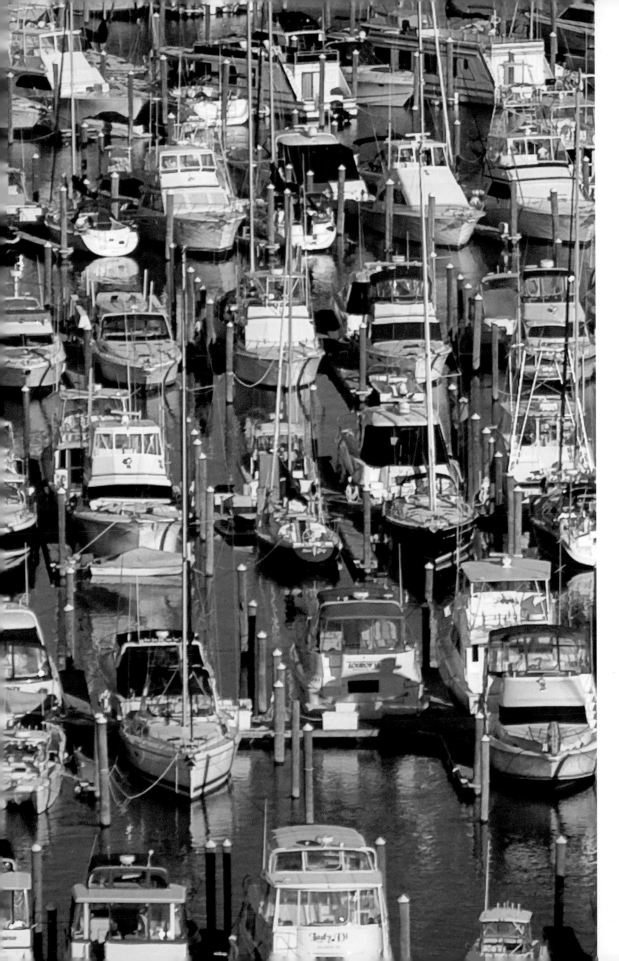

Hundreds of boats are docked in Great Egg Harbor, just south of Atlantic City. Its unusual name comes from the Dutch explorer Cornelius Mey who, in 1614, found the meadows covered with shorebird and waterfowl eggs.

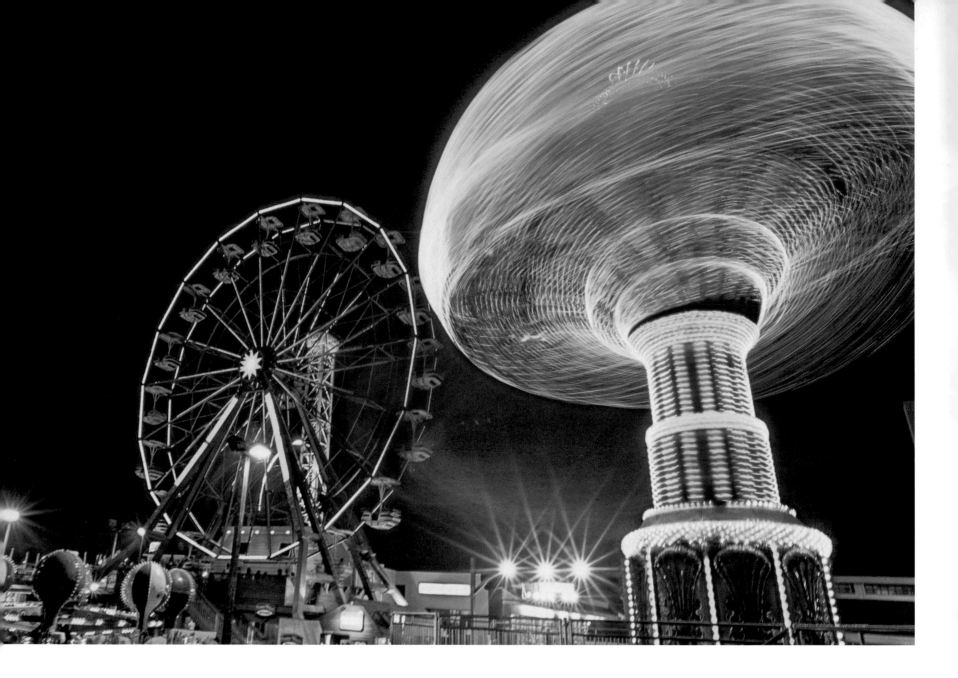

Founded in 1879 as a "no alcohol" resort, Ocean City still remains a liquor-free island and continues to be a popular destination for families. Located just south of Atlantic City, it offers an eight-mile-long beach, excellent sport fishing and a great variety of entertainment.

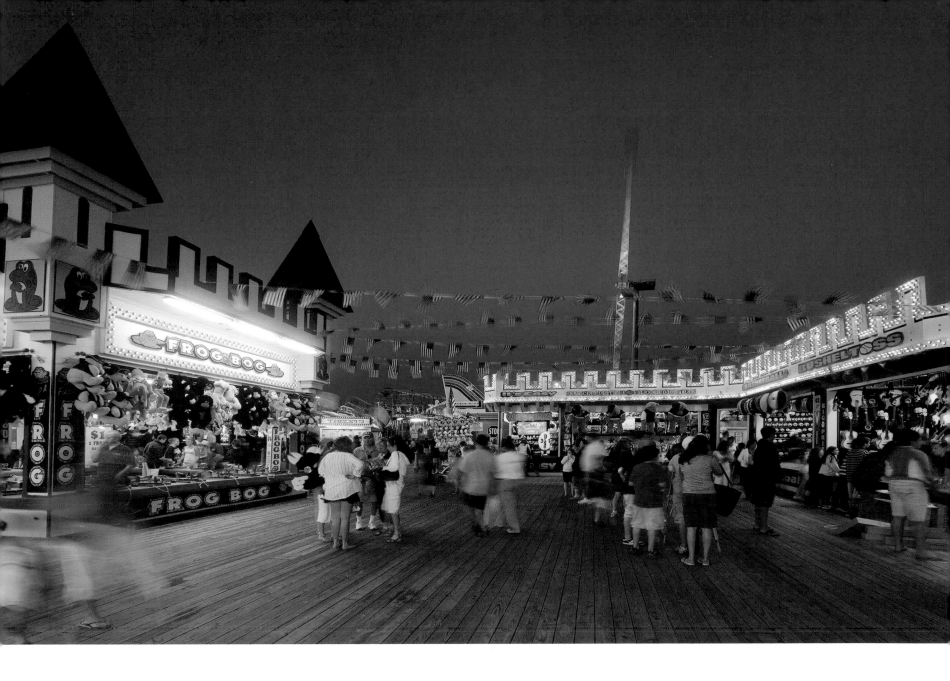

Every year, thousands of visitors come to stroll on the boardwalk at Seaside Heights on Barnegat Bay and enjoy the many games and amusements.

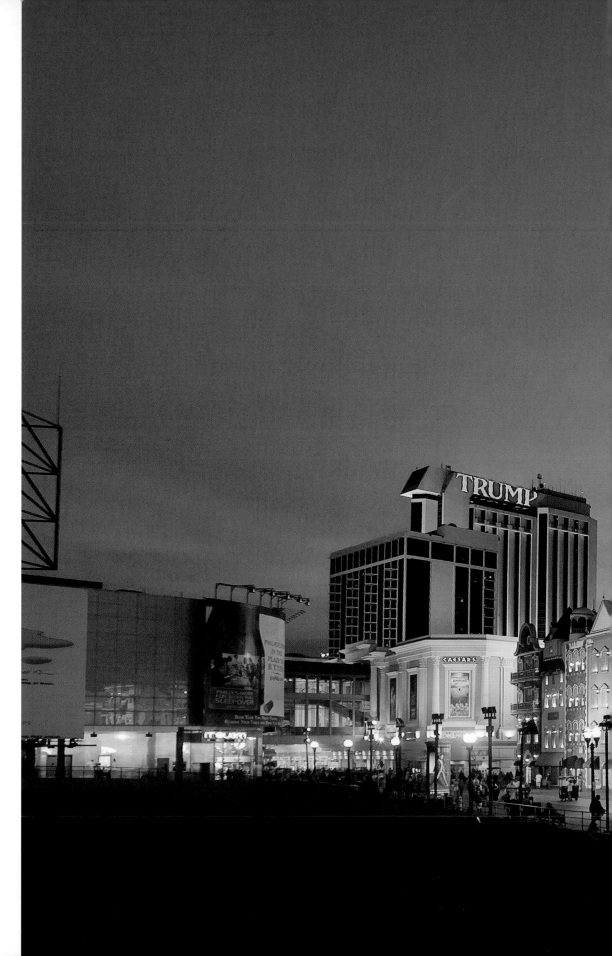

The world-famous Atlantic City boardwalk has been a popular family vacation spot since the 1800s. It has also become one of the hottest year-round gambling destinations.

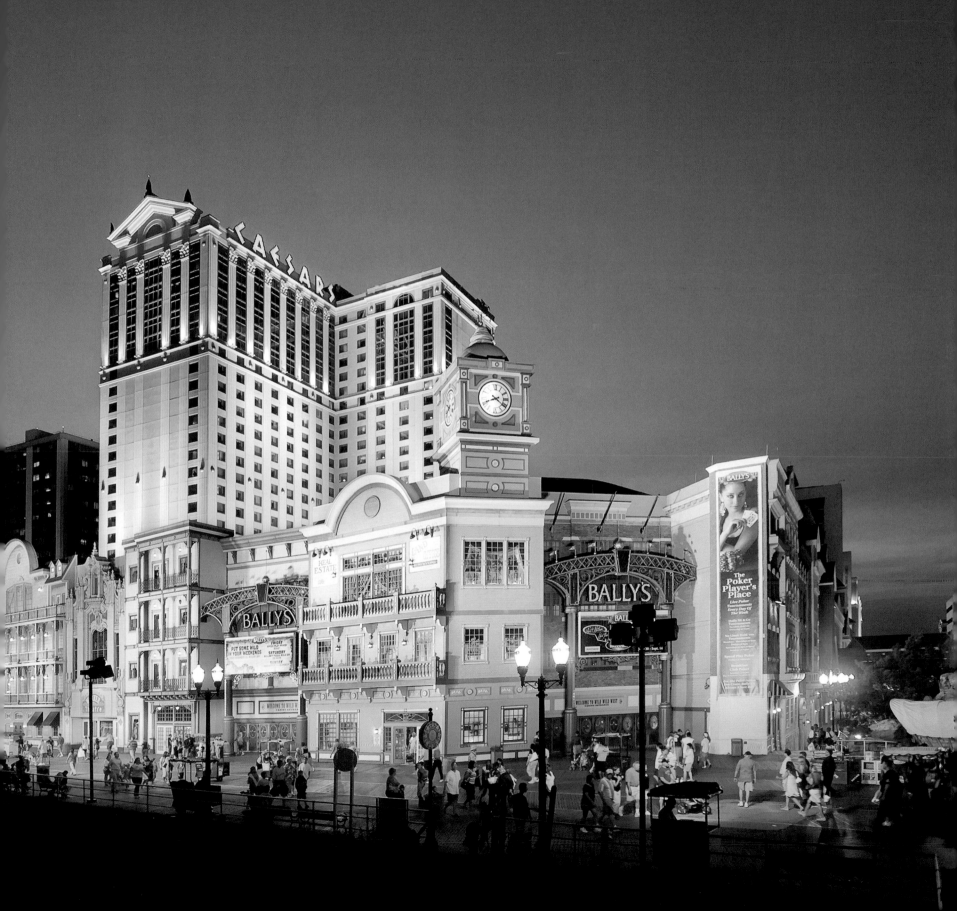

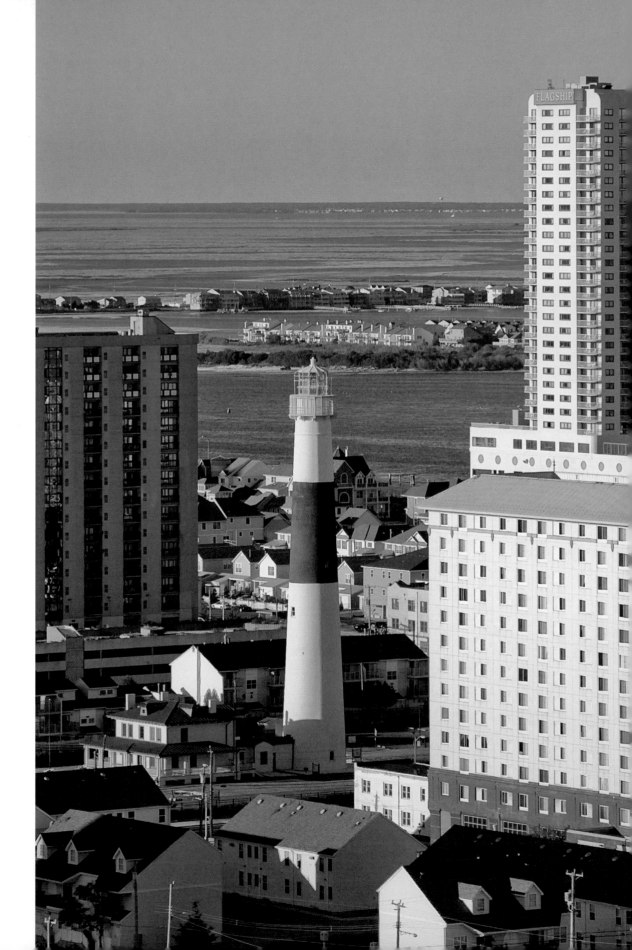

Times have changed since 1857. The Abescon Lighthouse is now surrounded by downtown Atlantic City. Visitors may still climb the 228 steps for a panorama of the city's skyline.

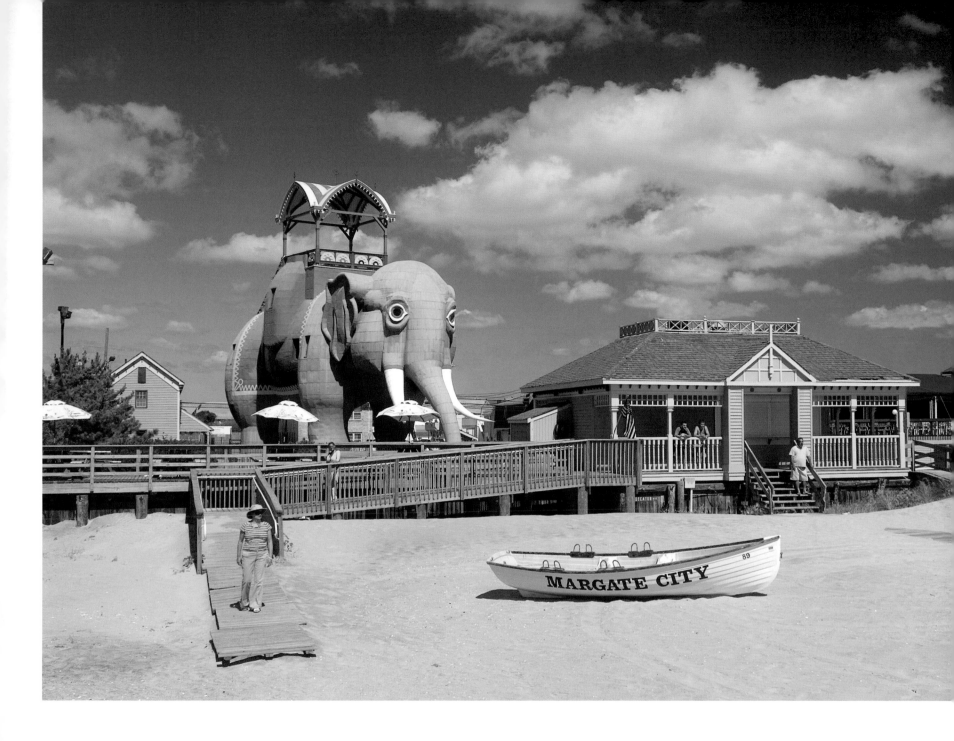

Lucy the Elephant is, in fact, a six-story wooden building located on the coast, just south of Atlantic City. Built by a developer, this 90-ton historic landmark has been a favorite attraction since 1881.

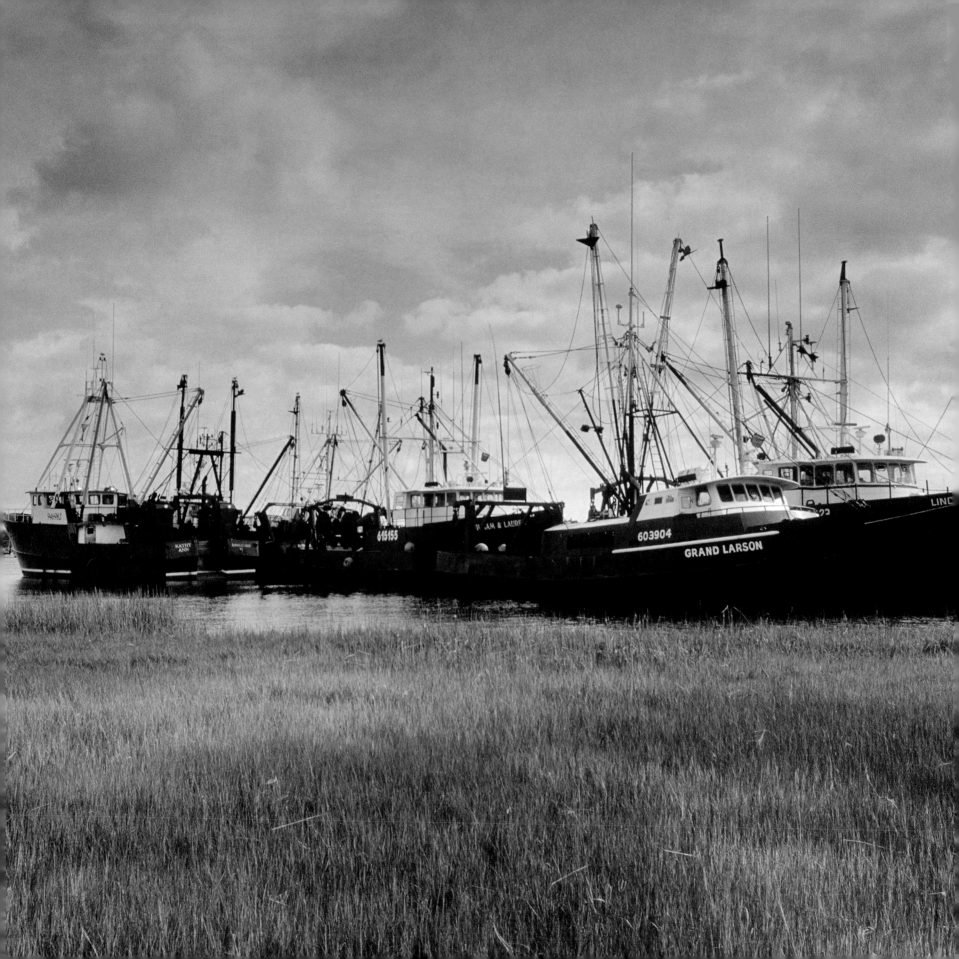

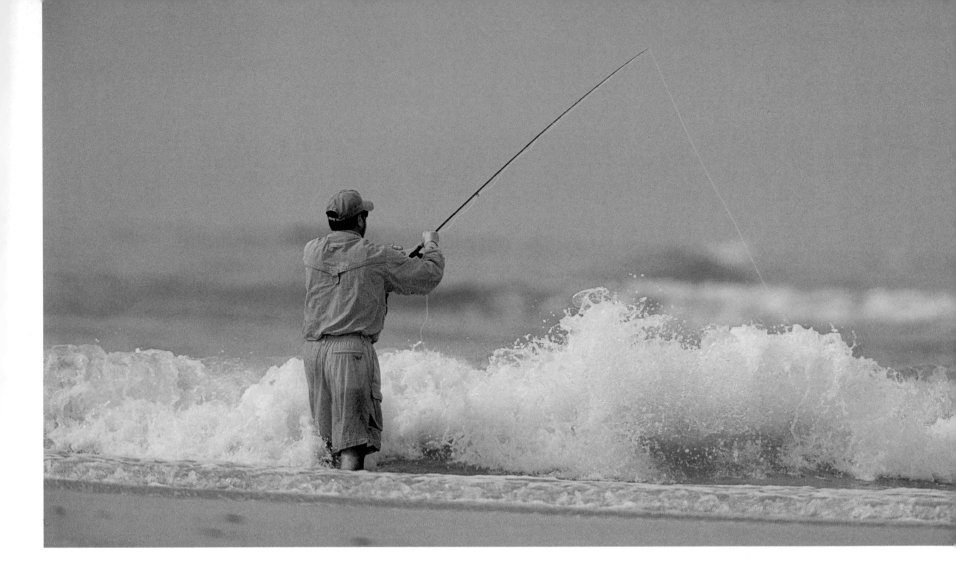

Many visitors take pleasure in surf fishing. At Stone Harbor off Cape May, this fisherman tries his luck in the crashing waves.

OPPOSITE PAGE: Fishing trawlers line up at the Barnegat Marina on Long Beach Island. Along with beautiful sea vistas and pristine beaches, the island offers great fishing for flounder, sea bass and bluefish, among other varieties.

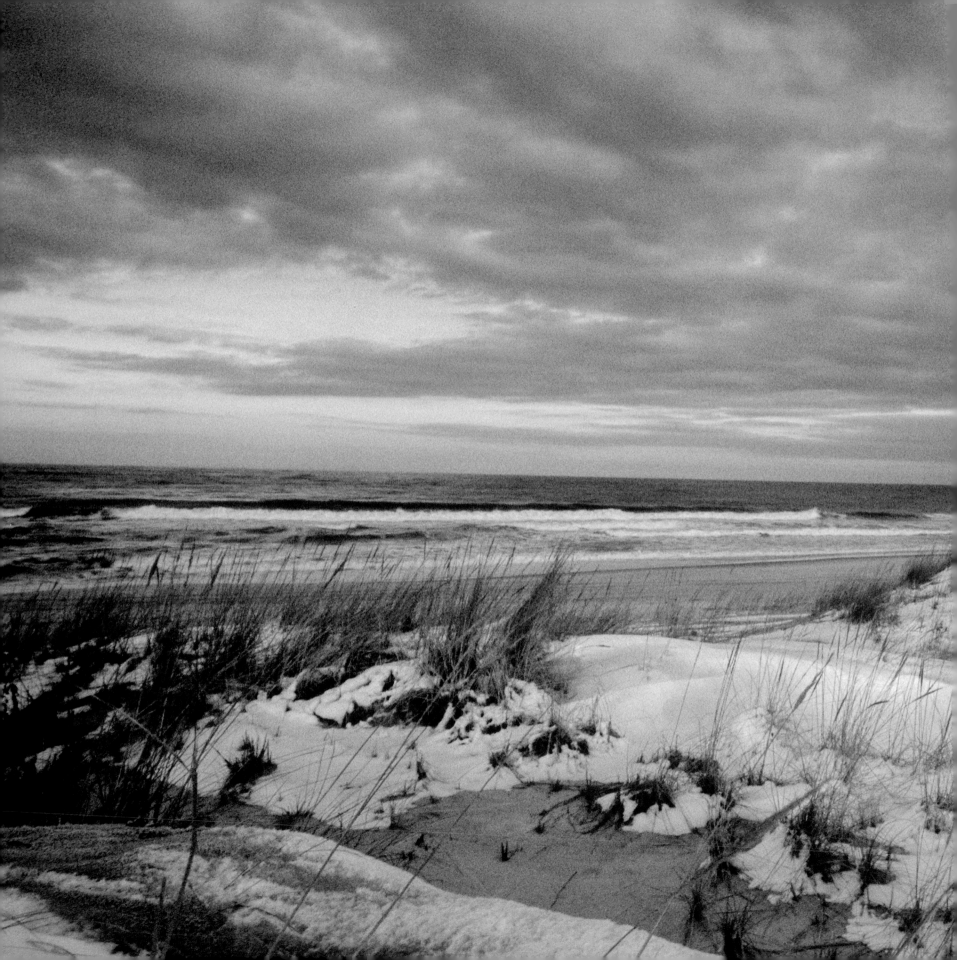

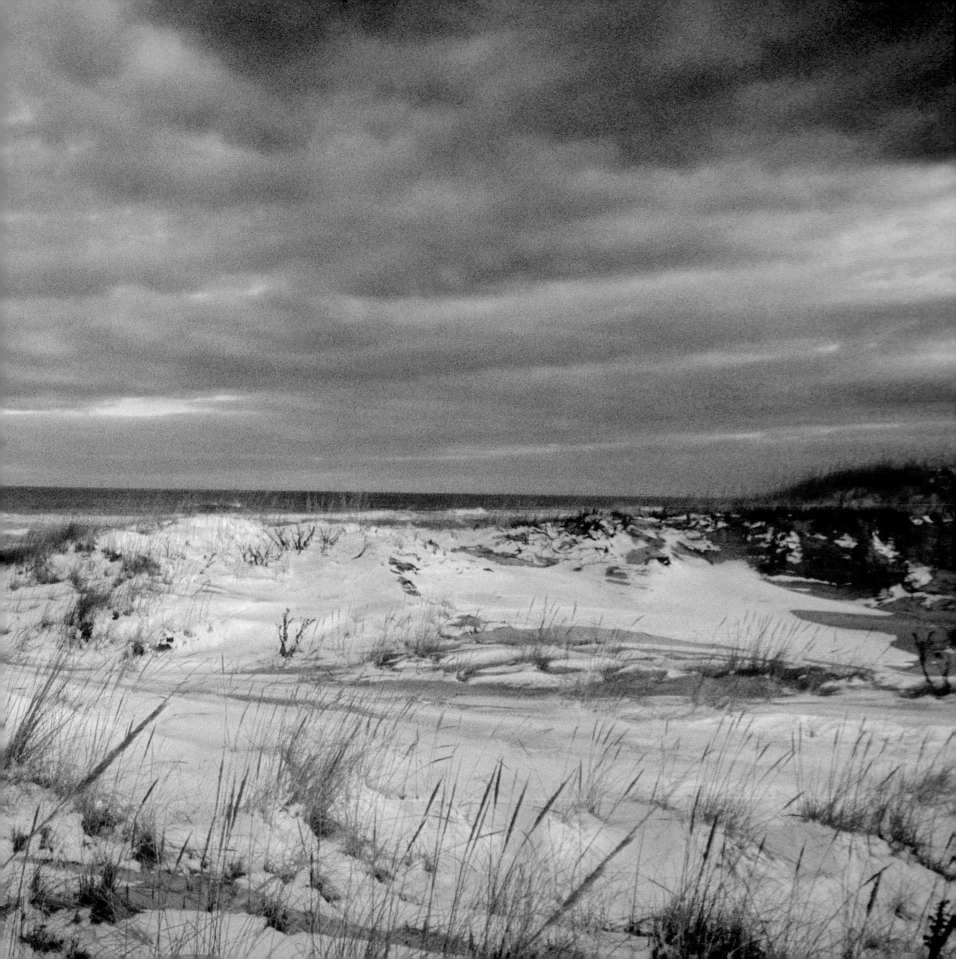

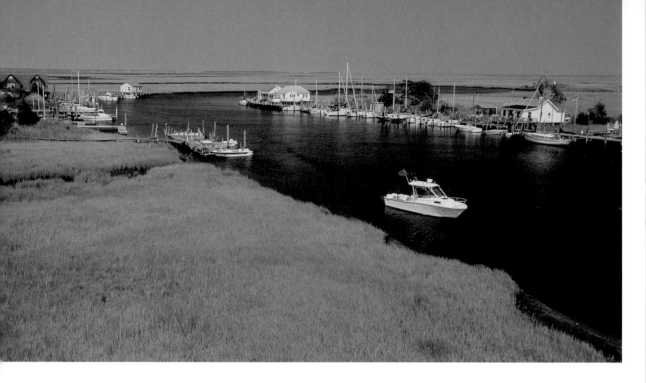

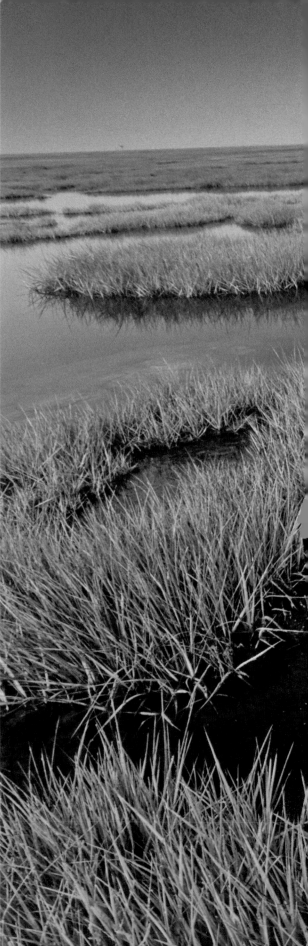

The Edwin Forsythe National Wildlife Refuge contains more than 43,000 acres of protected and managed coastal habitats for many animals, including some endangered species. The tidal salt marshes just north of Atlantic City are an ideal resting spot for thousands of migratory birds.

OPPOSITE PAGE: Salt marsh hay grows abundantly in the tidal salt water in Stone Harbor on Seven Mile Island off Cape May. These protected wetlands offer a safe natural habitat for many species of birds and wildlife.

PREVIOUS PAGE: A wintry sky looms over the snow-covered sand dunes on Island Beach. In the summer months, this stretch is one of the Jersey shore's most popular spots.

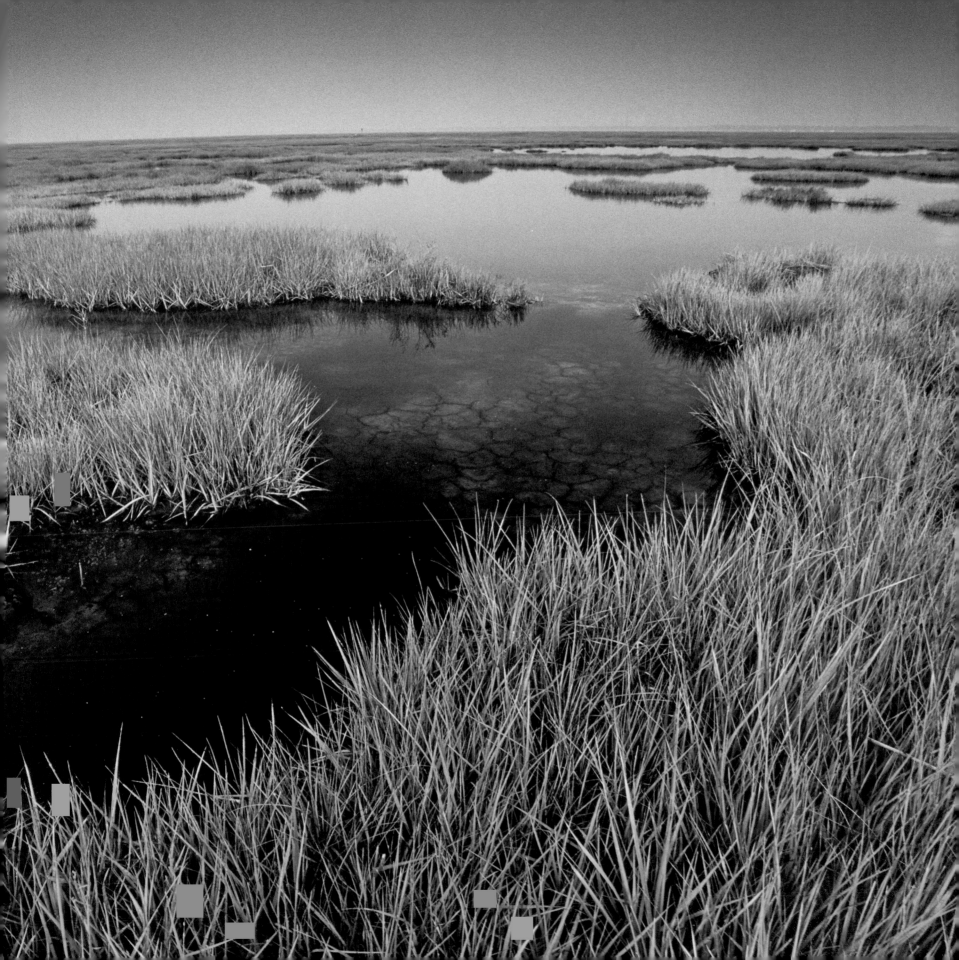

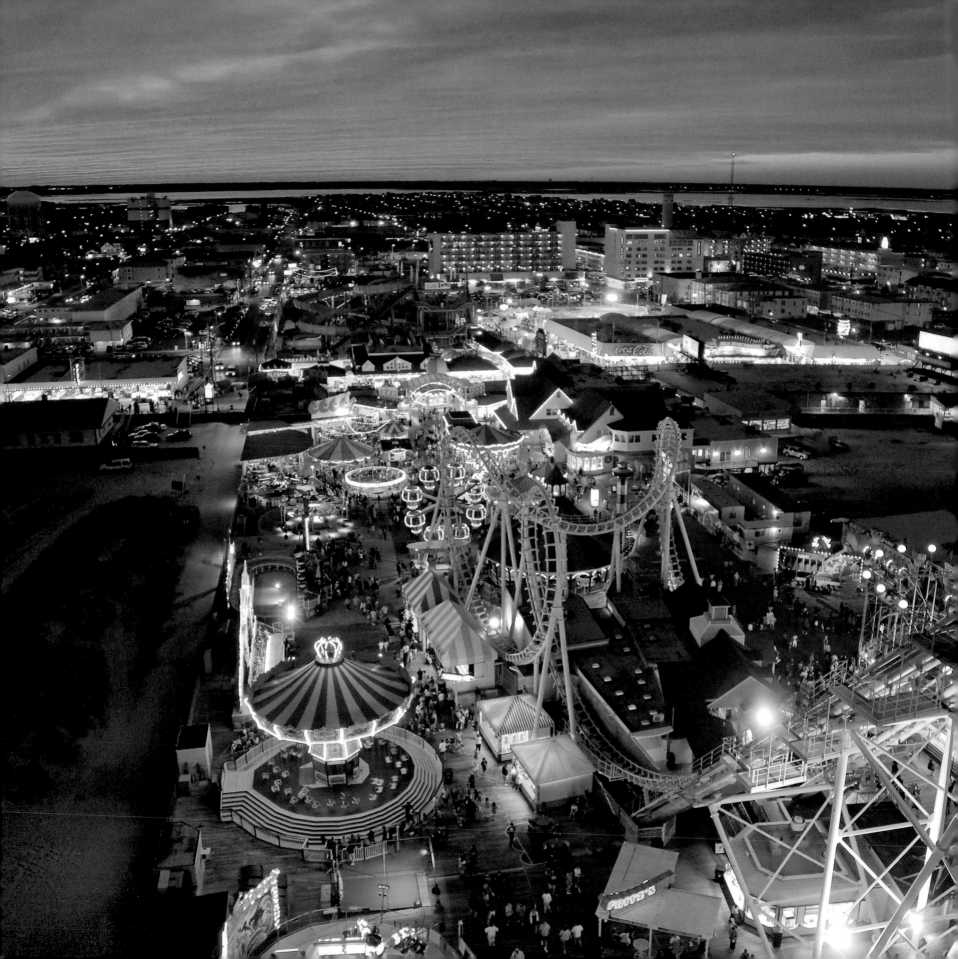

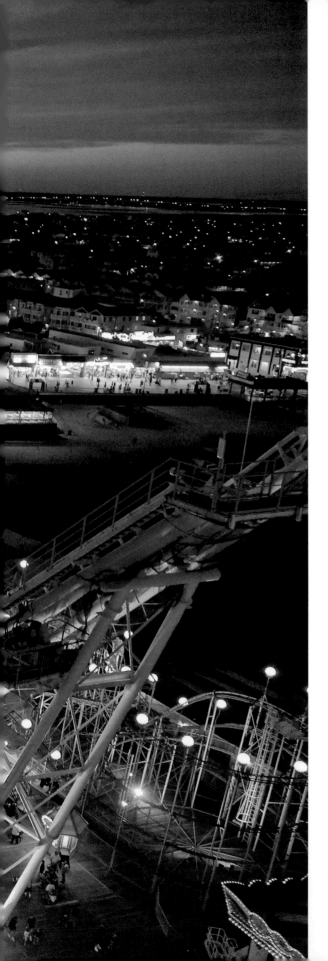

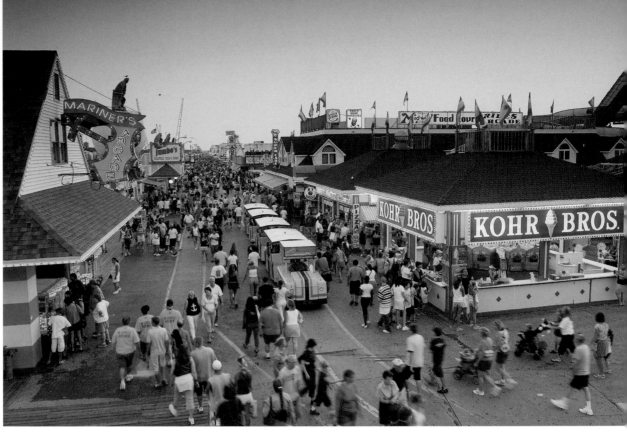

There isn't a cloud in the New Jersey summer sky as vacationers stroll along the Wildwood Boardwalk, enjoying the fun and food.

OPPOSITE PAGE: On the southernmost isle just north of Cape May, the Wildwoods offers a glittering array of thrills right along the beach. The boardwalk is almost two miles long – with shops, restaurants, nightclubs and three amusement piers.

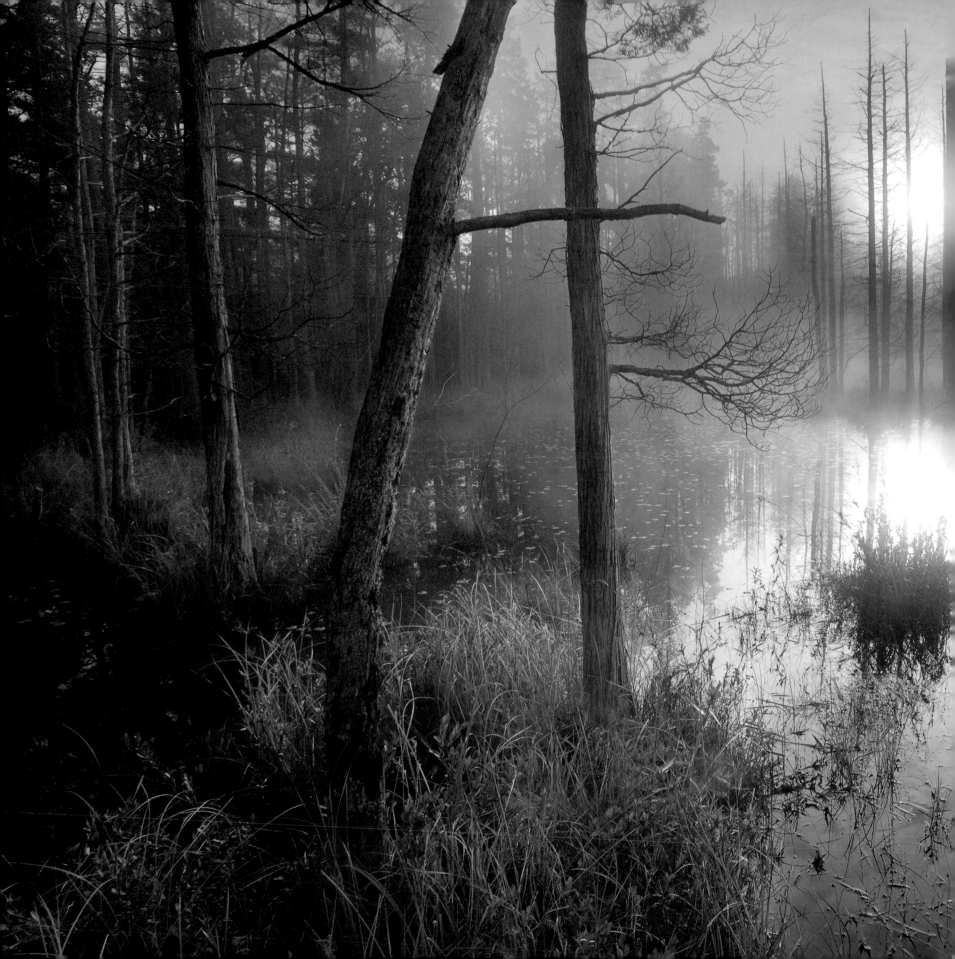

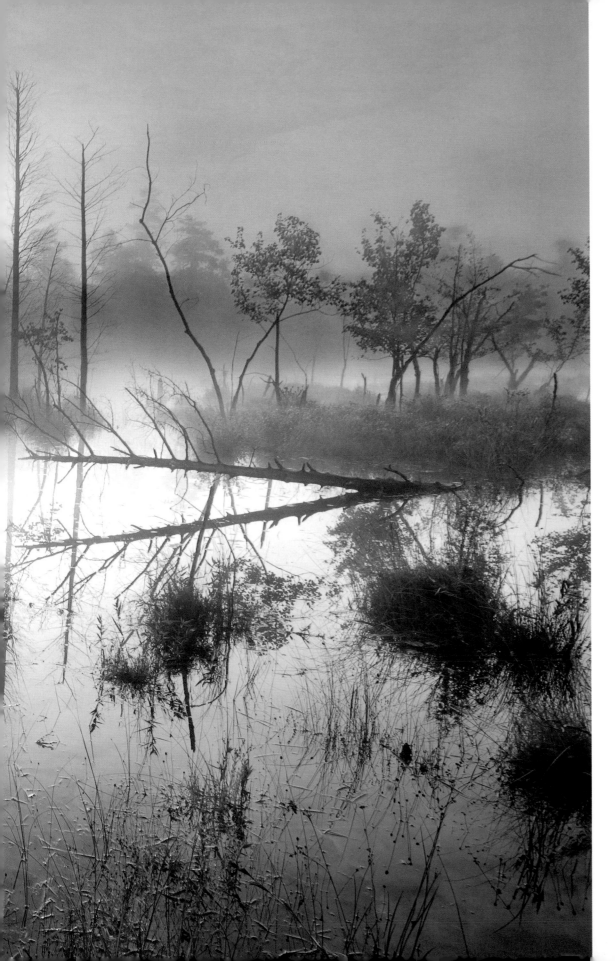

The extensive savanna marshes and numerous high, sandy banks of the Mullica River give this area its unique charm. Ideal for canoeing, the waterway meanders through the Pine Barrens – a national reserve that overlies more than a million acres of New Jersey's lower half.

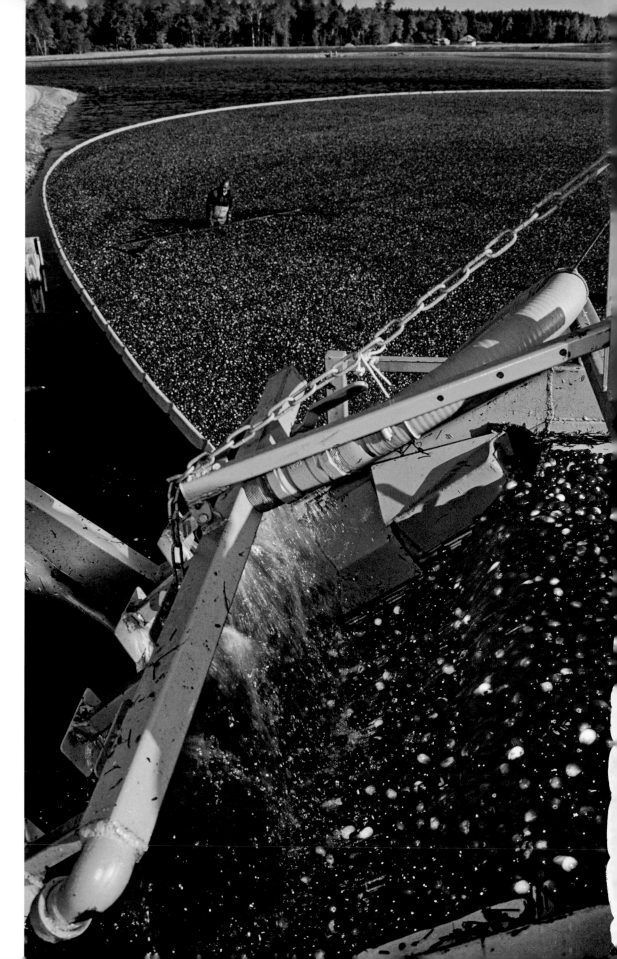

Cranberries don't grow in water, but because they float, the sandy bogs are flooded to make harvesting easier. Grown largely in the Pine Barrens in the lower half of the state, cranberries have been commercially raised here since the early 1800s.

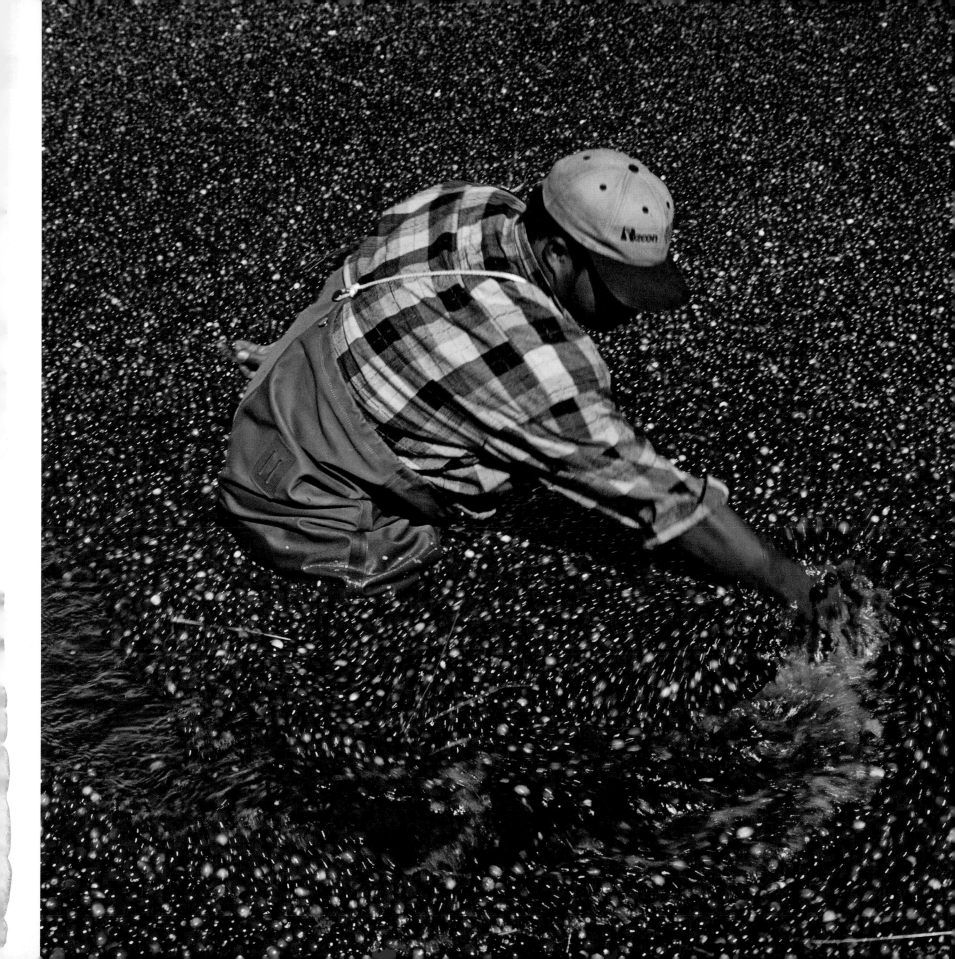

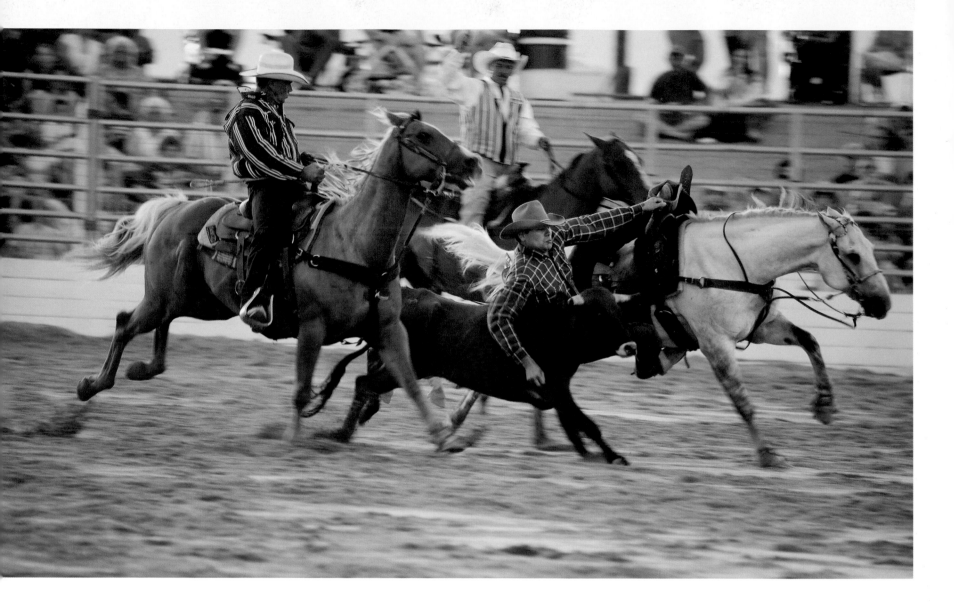

Starting in 1929, the Cowtown Rodeo in rural Salem County is renowned in the professional rodeo circuit. It is located inland, just eight miles from the Delaware Memorial Bridge.

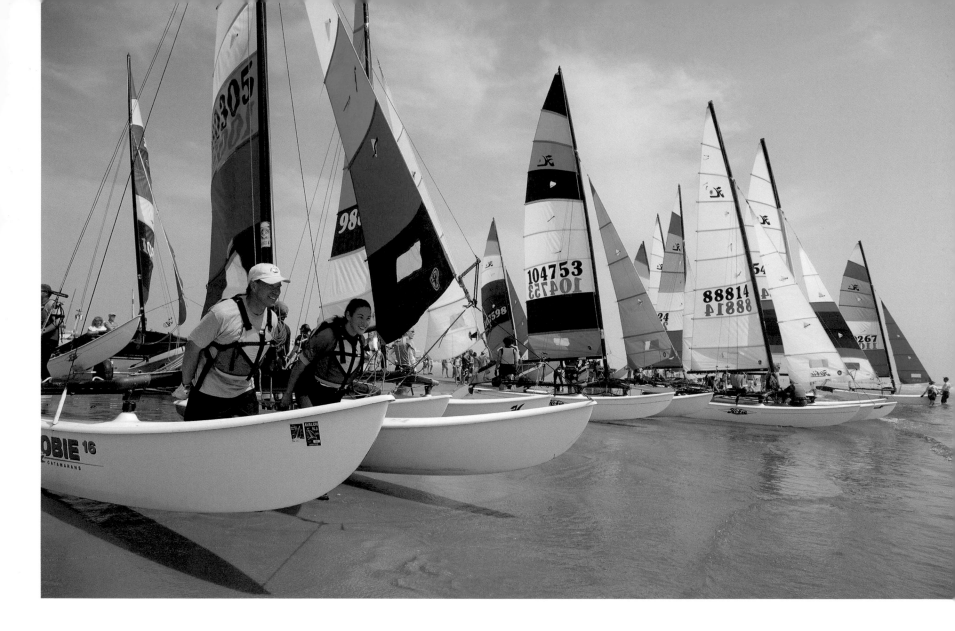

The annual Hobie Cat Regatta at Wildwood attracts sailing enthusiasts from across the country. The deep water and ideal conditions on the oceanfront make this regatta especially appealing.

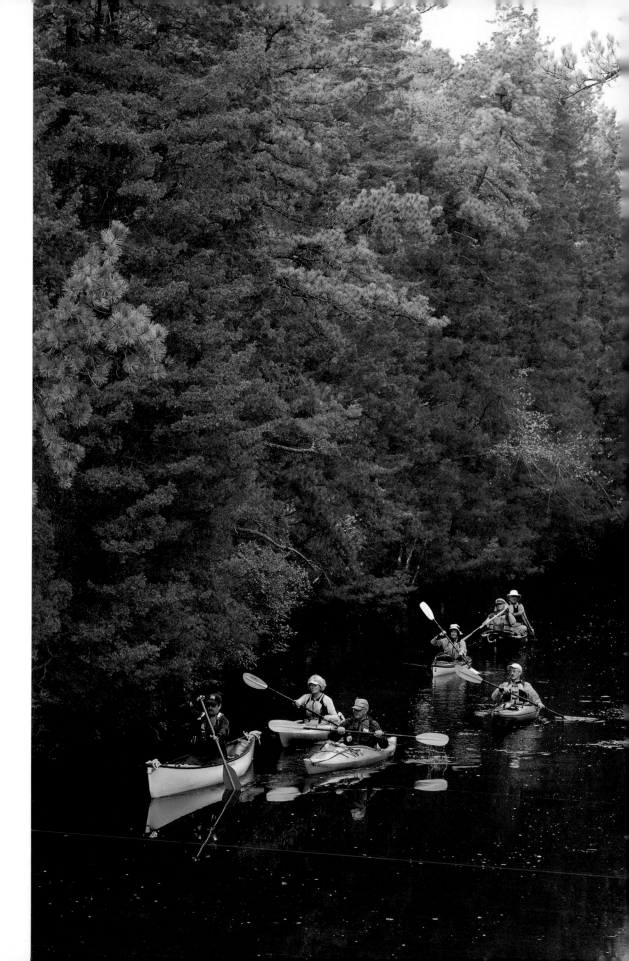

Paddlers drift along the beautiful Oswego River in the Wharton State Park Forest. There is excellent canoeing and kayaking on the expansive park's many rivers and ponds.

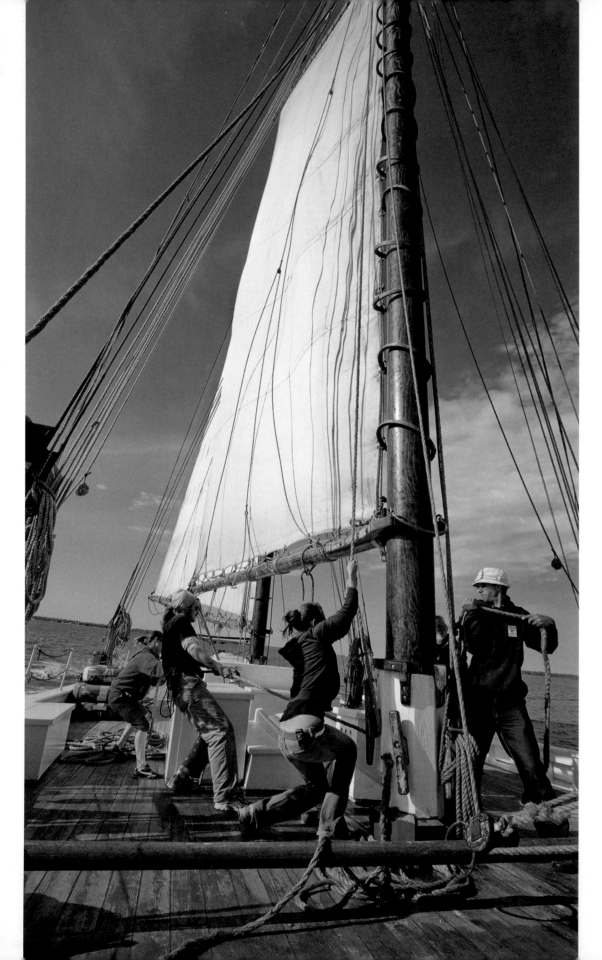

Deckhands hoist the main sail on New Jersey's official Tall Ship, the *A.J. Meerwald*, which was first launched in 1928. It is 115 feet long, made of "oak on oak" and welcomes passengers willing to assist the crew as it sails in the Delaware Estuary.

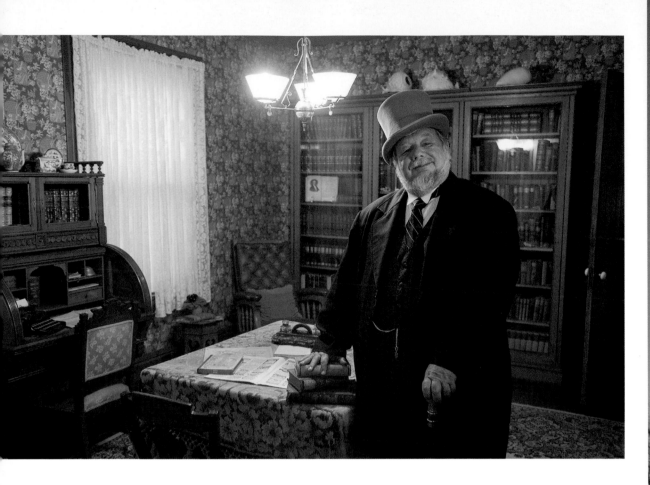

Visitors meet Dr. Emlen Physick himself (actor) as they tour this grand Victorian mansion, built in 1879 and designed by renowned architect Frank Furness. The house and the nine outbuildings on the four-acre Cape May estate have been beautifully and accurately restored by the Mid-Atlantic Center for the Arts (MAC).

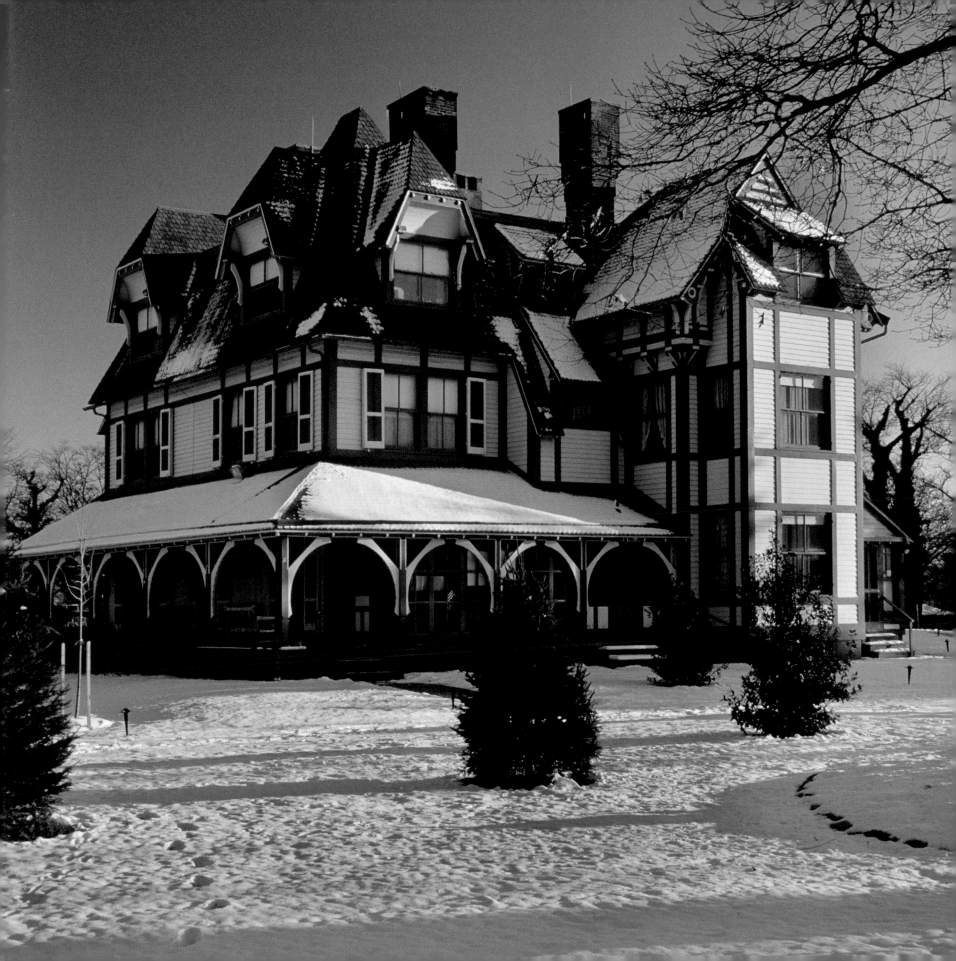

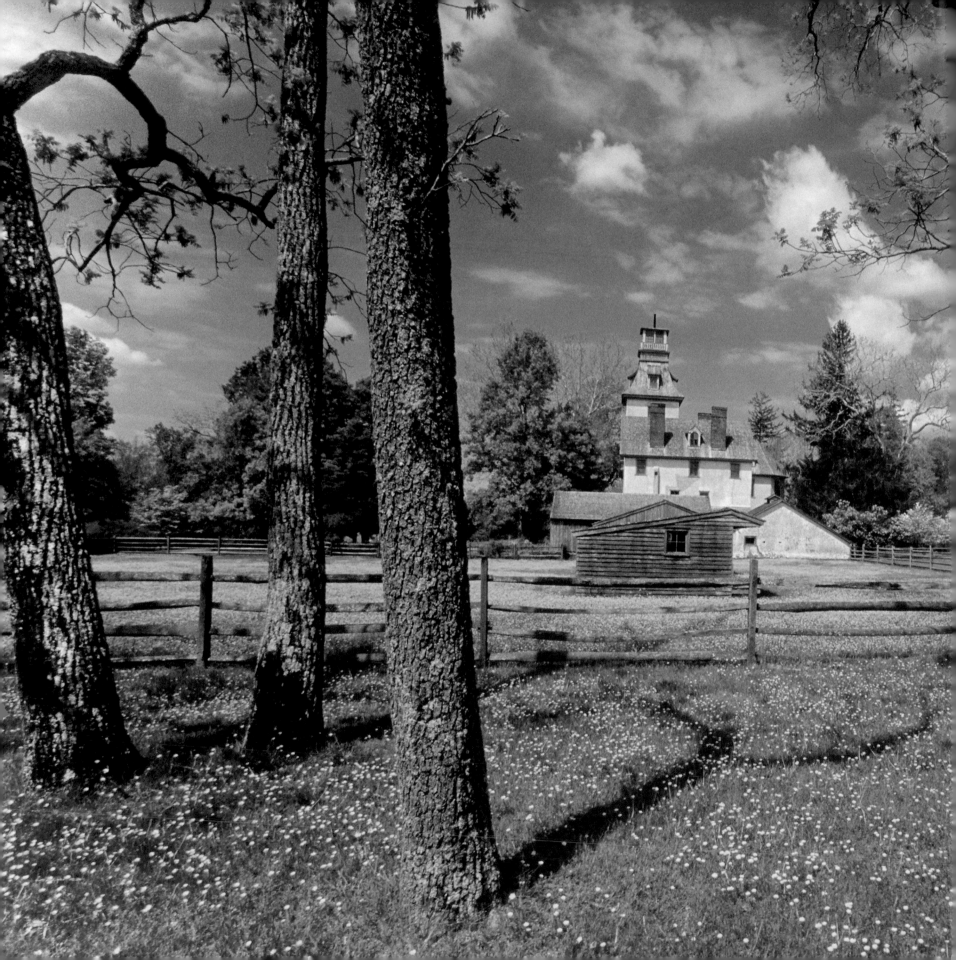

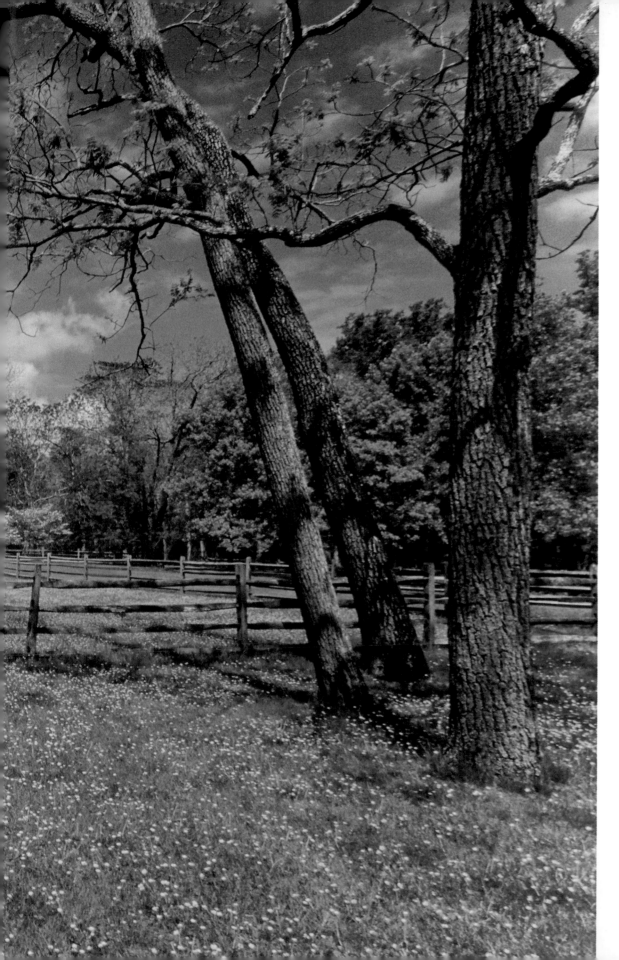

Travelers step back in time when they visit the restored buildings of Batsto Historic Village in the Wharton State Forest. Established in 1766 as an iron foundry, the village produced household items such as cooking pots and kettles as well as military supplies during the Revolutionary War.

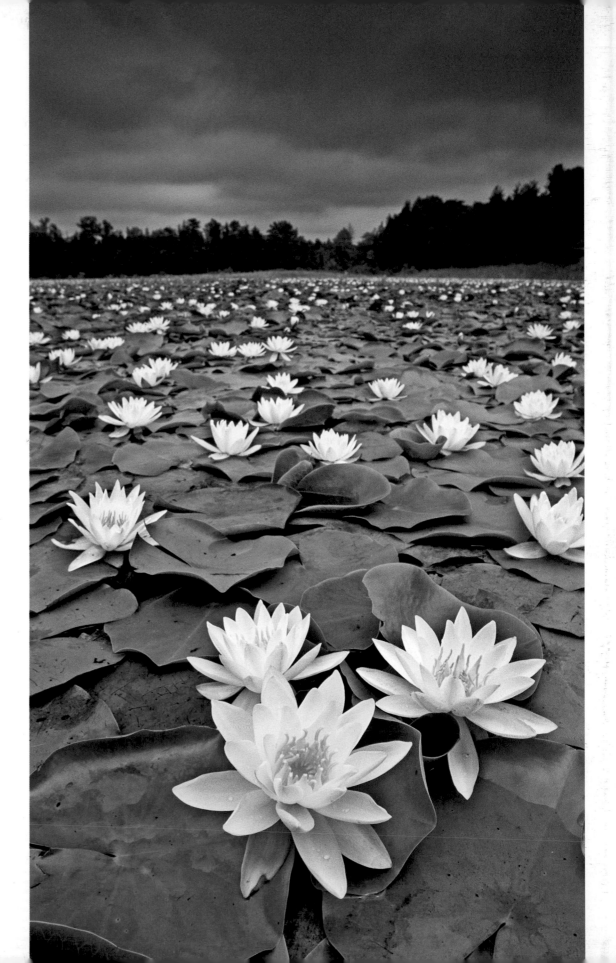

American white water lilies blanket a
section of Dividing Creek, a tributary of
the Delaware River in southern New Jersey.
The Chippewa Indians used the roots of
the white pond lily as medicine.

The largest population of horseshoe crabs
in the world lives in the Delaware Bay at
the south end of New Jersey. Each year,
from mid May until late June, these ancient
critters come ashore only to lay their eggs in
the sand, attracting hundreds of shorebirds,
birdwatchers and the just plain curious.

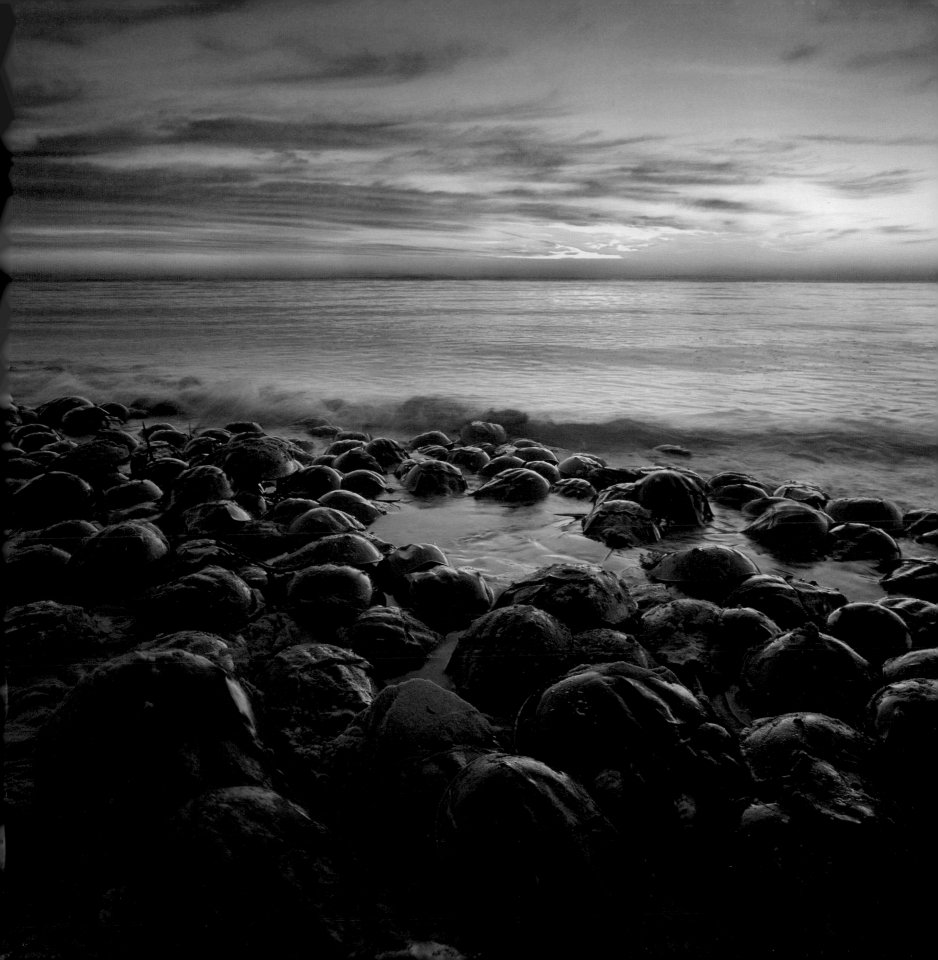